Introducing Abstract Picture Making

Introducing Abstract Picture Making

ROBIN CAPON

Watson-Guptill Publications New York

First published in the United States of America
1973 by *Watson-Guptill Publications*
a division of Billboard Publications Inc
165 West 46 Street, New York, NY 10036

Copyright © 1973 by Robin Capon
First published 1973 in Great Britain by
B T Batsford Limited
4 Fitzhardinge Street, London W1H 0AH

Manufactured in Great Britain

**Library of Congress Cataloging in
Publication Data**

Capon, Robin
Introducing Abstract Picture Making
Bibliography: p
1 Art, Abstract. 2 Art – Technique.
3 Art – Study and Teaching. I Title
N7433.C33 741.2 72–7366
ISBN 0–8230–6097–7

Contents

Introduction

Abstract is a term which many people find difficult to understand. Abstract pictures, therefore, are equally difficult for them to appreciate. Such pictures rely for their effect on the viewer's awareness of colour and shape which, after all, is the basis of most art. As Plato said, 'I do not now intend by beauty of shapes what most people would expect . . . but . . . straight lines and curves and the surfaces or solid forms produced out of these by lathes and rulers and squares.' Cézanne, too, looked for the cone, the sphere and the cylinder in Nature. Abstract pictures must excite the vision.

Children probably accept this much more readily than do most adults. To help appreciate 'abstract' art, one should look at some of the basic movements in the history of art which led to abstract painting, and study the work of the 'old masters' of abstract art. Linking work done in the classroom with that of famous artists is often very necessary and valuable.

The book should be read and considered as a whole. There is little point in isolating one particular technique merely as an interesting way of passing time. As with all education, present work should relate to what is to come and should grow from what has passed; it should fit into an over-all plan. With abstract work this is sometimes difficult, but it can be done. For example, work can evolve from the study of a particular artist. It can be an extension of the study of natural forms, of aerial photographs, or the use of the microscope in biology. It can be based on simplification of objects or themes already interpreted in a realistic way or it can be used purely as a form of self-expression.

The book is confined to abstract pictures. The author hopes it will stimulate an awareness of the possibilities that such pictures offer, and will prove there is a place for this type of work in art education. By explaining various techniques, a whole range of exciting abstract pictures is possible. The methods illustrated and described are mostly simple ones and may be worked with limited equipment and inexperienced students.

The illustrations along with the text, help to express clearly a technique or idea. These should not necessarily be considered as finished products, for very often the concept behind them could be carried much further. When the basic technique is understood the reader is encouraged to develop it and to experiment.

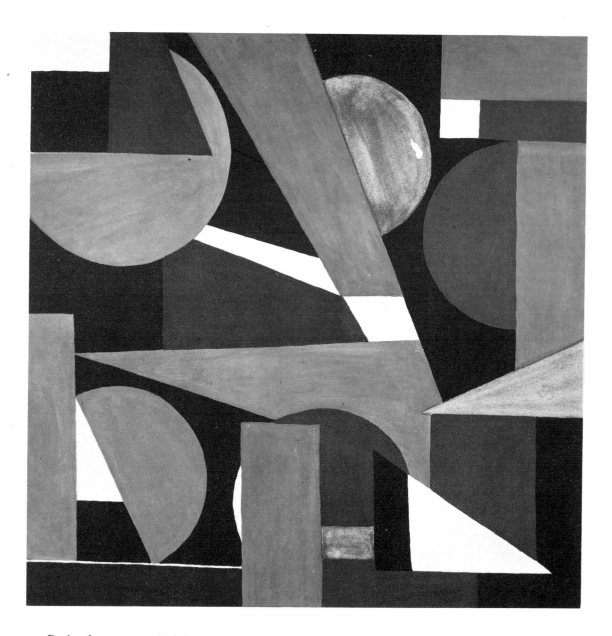

1 *Design from geometrical shapes*

8

1 Painting

Paintings

A variety of techniques for creating paintings is described and illustrated on the following pages. Such paintings can often be linked with and stimulated by other ideas. The study of interesting visual material will often inspire a painting, as mentioned in the Introduction. Many such stimuli come from nature: a virus magnified by an electron microscope, for example, might inspire an action painting. *Figure 7*, on page 13, could well be based on the study of wood grain. Indeed some of the pictures made by the artist Max Ernst were so inspired.

The size of the work and the media to be used are left to the discretion and ability of the individual. Abstract work is often most effective on a large scale.

Hardboard, fibreboard, composition board, canvas, card or paper could be used as supports; these need not necessarily be white.

Emulsion, gloss, polyvinyl acetate (pva), acrylic paints, oils, poster paints, powder (dry pigment) and watercolour are all suitable paints.

Often the support and paint must be chosen to suit the particular technique being employed. For example, if a thick, textured result is required, it would be pointless to use watercolour on paper.

Brushes are not the only painting tools. Paint can be applied direct from the tube, with a knife, by using pieces of rag, card or other textured material, with a spray-gun, or in a number of other ways.

Using pure shapes

The pure abstract design can be used in many ways as a basis for painting.

Figure 1 was designed with pencil, ruler and compass, using geometrical or near-geometrical shapes. In this case the shapes were not allowed to overlap; instead the whole consists of separately drawn parts. The parts of the design are then painted in. A restriction of colours to just two or three is almost always very effective. Superimposed thin black lines can be used to enhance the result.

With this type of work a careful approach is necessary. It may serve as a useful exercise for investigation into colour: the shapes could be painted in complementary colours, for example, or in a range of one colour, say blue.

A painting such as this may also serve as the basis for other work described later in this book. For example, it can be cut and then assembled in a different way.

Paints such as emulsion or poster, which are easily controlled and produce solid areas of colour, are most suitable for this type of painting.

The design in *figure 2* is based on overlapping geometrical shapes.

2 *Design from overlapping geometrical shapes*

3　*Repeated shape*

Repeating a shape

In *figure 3* the same shape has been repeated in various positions to form the design, and in some parts outline shapes have been superimposed. The original shape can be a template cut from card.

Many variations are possible with unit repetition and this is explained later in the book.

Freely drawn shapes

Figures 4 to 7 illustrate four possibilities using freely drawn shapes. These examples are suitable for small or large scale work.

Figure 4 is basically the same as *figure 1*, page 8, the shapes here being composed from imagination rather than being geometrical. Again, as well as the shapes, importance must be attached to colour and care in execution.

Similar designs can be made with overlapping shapes or even based on a story or allegory. The work of the artist Joan Miró may serve to illustrate this.

In *figure 5* the design was painted directly on to the support and is made from a series of freely painted black lines which were then subdivided to form the various shapes. The example represents a freer expression of shape and colour; the precision noticed in some earlier examples is not necessary here. Many variations on this theme are possible.

The design illustrated in *figure 6* is simply based on lines drawn from top to bottom of the paper at irregular intervals. The shapes thus formed are carefully painted in. Similar designs can be made by drawing lines in other directions, for example, diagonally, or in two or more directions to cause shapes made from overlapping.

Working from the centre is another possibility. In *figure 7* the paper was first folded in half. A meandering line was then drawn either side of this centre fold, the lines being repeated outwards to the edge of the paper. The spaces between lines should be varied and they are coloured accordingly. Again, more complicated variations are possible.

4 *(opposite above left)* *Freely drawn shapes*

5 *(opposite above right)* *Design from freely painted black lines*

6 *(opposite below left)* *Design from freely drawn lines*

7 *(opposite below right)* *Designing from the centre*

Designing with a continuous line

The basic design of a painting may be composed simply of a continuous line which is made to overlap on itself in various ways thus producing shapes.

Figures 8 and 9 illustrate two examples of this.

Designing with random dots

Figure 10 is more complex. Here the design was built up from dots placed at random on the paper. Approximately thirty dots were used. Using a pencil and straight-edge the dots were then joined up. A further series of dots was then made and these were joined up in such a way as to overlap on the first and create pointed shapes.

Other designs can be made by varying the way in which the dots are joined up or by making shapes from different groups of dots.

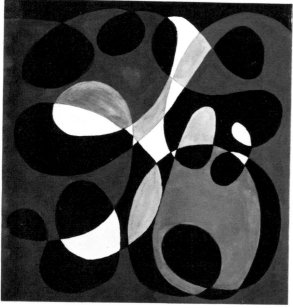

8 *(above) Continuous line design*

9 *(below) Continuous line design*

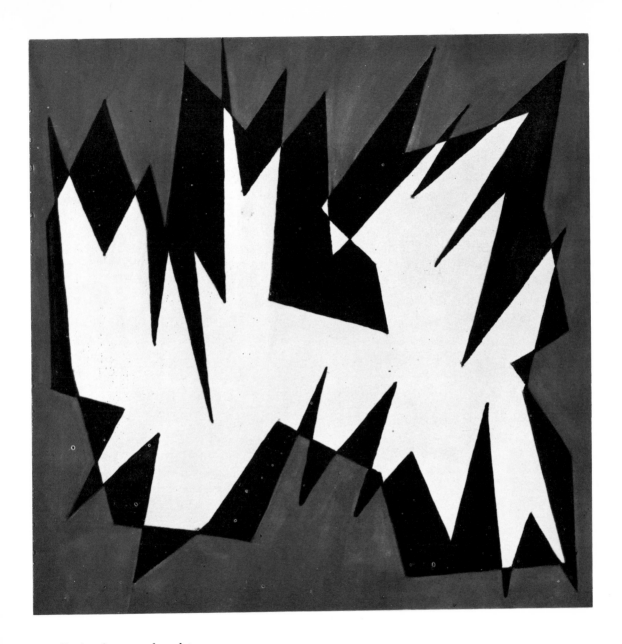

10 *Design from random dots*

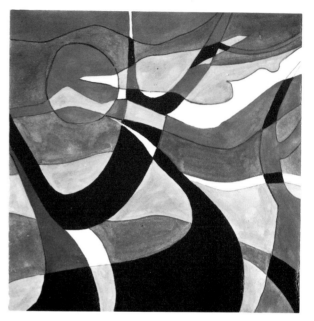

Using overlapping shapes

Interesting results are achieved by making the design from a shape repeated in various ways and allowed to overlap. The overlapped parts create different shapes within the picture. Templates can be made from card or found objects used to draw round. In *figure 11* the design has been made by drawing round a pair of scissors.

Care, both in drawing and painting, is important. Again, suitable paints and brushes must be used. Such designs are often intricate and therefore best confined to a small scale.

11 *Using overlapping shapes*

12 *Semi-abstract design*

Designs based on simplification—semi-abstract

Often a well-worn idea can be made more interesting by simplification and the use of colour. However, it is surprising how difficult it is to simplify an idea, or even another picture, and some foundation work will be necessary. One must reduce the picture to its barest essentials, using the minimum of line and shape.

Figure 12 represents a road passing between trees, across fields and into the distance where the sun is setting beyond the hills. Shapes have been deliberately overlapped and superimposed, making a picture which is simple in concept and design, yet visually quite interesting. The shapes have been painted as precise, flat areas of colour. Alternatively, it is possible to paint such pictures in a more expressionist manner.

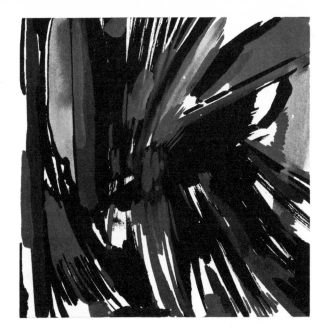

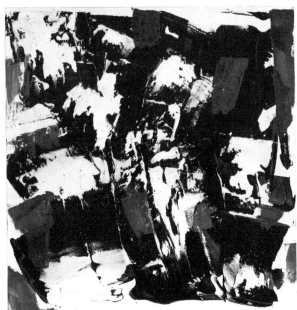

Free expression

Figures 13–15 illustrate freer methods of expression. In all three examples the design has been allowed to grow on the paper. There was no preliminary planning. The results were built up from a single mark on the paper; as the design developed shapes were altered and colours changed until a satisfactory conclusion was reached.

In *figure 13* different sizes of brush have been used with a limited range of colour.

Constrasts can be achieved between shapes, thickness and texture of paint, and intensity of colour. Colours can be overlapped or superimposed; several layers of paint in one area might contrast with a wash of paint in another area. One can make brush strokes of various widths and lengths. In the example, the white areas are just as important to the total effect as the coloured shapes around them.

Very little of this type of work is achieved by accident; the artist is very much in control. He must be self-critical and exactly conscious of what he is doing. Every brushstroke creates a new picture.

It is very often a good idea to have, or develop, a basic theme at the back of one's mind. In *figure 13*, for example, most brushstrokes radiate from an area left of centre.

13 *Free expression*

14 *Abstract expressionism*

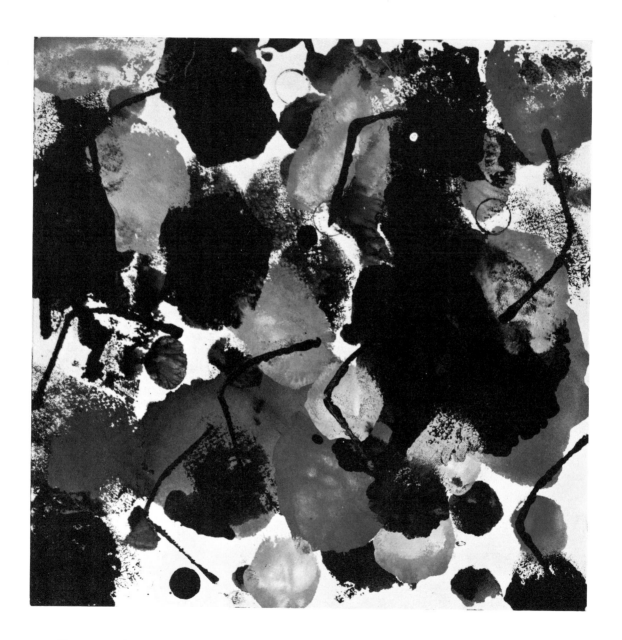

15 *Free expression*

In *figure 14* the paint has been scraped on with various lengths of card. Thick paint was used. Textures develop where additional layers of paint have been scraped across existing ones. Each colour should be allowed to dry before further paint is applied.

In any work based on the techniques illustrated in these three examples, thick paint should be used and the work done on quite a large scale. Polyvinyl acetate (pva) and acrylic paints are particularly suitable as they are quick-drying.

Brushes were not used in *figure 15*. Here the paint has been applied with cloth pads, a bent piece of card, and a small metal tube. In consequence, various textures are achieved and the painting becomes visually more exciting. Pads made from coarse material, such as hessian (burlap) will give very definite textures. The pad is impressed into some paint and then pressed on to the canvas or other support being used. Such things as rollers, combs, cardboard tubes, toothbrushes and even fingers may also be used as painting tools. Textures can also be made by impressing various objects into the paint. Often the best results are achieved here, provided the paint is allowed to dry out a little beforehand.

Allowing paint to run

With techniques such as those involving blown or dribbled paint, or paint that has been allowed to run, results are more accidental. However, the artist still controls the final result and must decide whether to accept or reject anything accidental. In the examples, *figures 16 to 18*, white paper has been used, but coloured paper could be used or the support prepared by spraying or painting beforehand. Thin paint is required.

In *figure 16*, paint has been dropped on to the paper, which has then been tilted at various angles. The paint will, of course, run from the original drip to the lower edge. The 'runs' can be controlled by tilting the paper in different directions. A variety of colours can be used but each colour should be allowed to dry out before the next is applied.

The paper in *figure 17* was placed on a drawing board which had been positioned at an angle of about forty-five degrees. When a brush loaded with thin paint was pressed against the top of the paper, the paint ran down it.

The design illustrated in *figure 18* is an extension of this. Here the paint has been allowed to run down the paper, and when it was dry, the paper was turned and second runs of paint made so as to cross the first. The original brushmarks have been cut off and some shapes filled in to contrast.

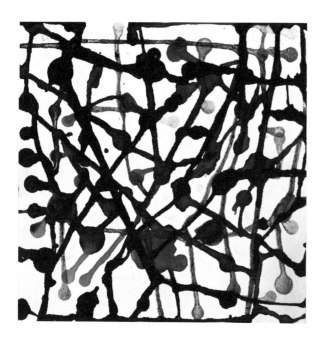

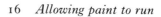
16 *Allowing paint to run*

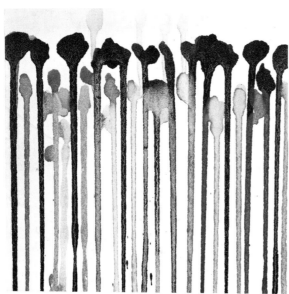

17 *Design from 'runs' of paint*

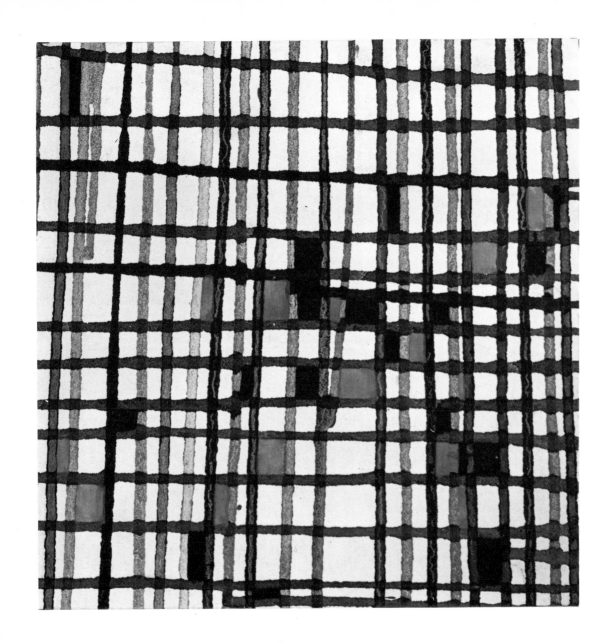

18 *Design from 'runs' of paint*

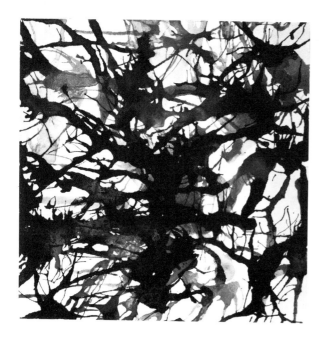

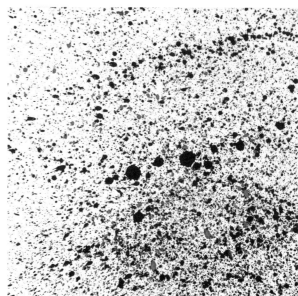

Blown designs

In *figure 19* paint dripped on to the surface has been blown so that it splays out in various directions. The results here are, of course, largely accidental, but can be fascinating. More control can be achieved by blowing through a drinking straw. Different colours can be applied and again, thin, free-flowing paint will be required.

Flicked paint

Paint can be flicked or thrown at the canvas or other support. Plastic bottles of paint or converted plastic liquid detergent containers can also be used. A variety of sizes and types of brushes will give different effects. More control is possible with a fairly dry brush.

In *figure 20* the paint was flicked on from a brush. The brush was held vertically in front of the painting and paint flicked from the hairs.

Spray painting is described later in this book in the section on templates.

19 *Blown design*

20 *Flicked paint*

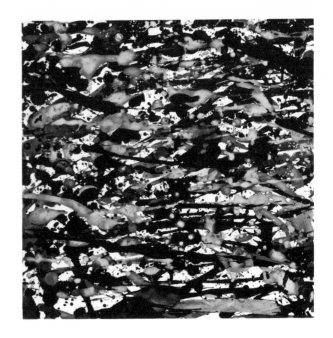

Action painting

Action painting normally involves a combination of techniques. Paint can be dribbled, flicked, thrown, splashed or sprayed on to the canvas. Unusual painting tools may be used and different textures achieved. *Figure 21* is an example, and is mainly the result of dribbled and flicked paint.

21 *Action painting*

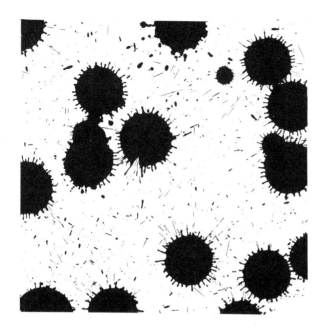

Dripped paint

In *figure 22* paint has been dripped from a brush held above the paper. The brush must be loaded with thin paint. It should be held vertically above the painting, the hairs being squeezed from top to bottom, so forcing a drop of paint to fall off. The size of the blob of paint will depend upon the distance the brush is held above the picture and also the size of the brush.

Although one can roughly control where the drop of paint is to fall the result must have an element of accident about it. Various colours can be used and a dropper used instead of a brush.

Variations of colour, brushes and distance from the surface have been used in *figure 23*.

Blot designs

Blot designs are best done on cartridge (drawing) paper, which is reasonably absorbent, with a quick-drying paint, such as poster colour. The paper can either be folded or two separate sheets used.

In *figure 24* the paper was folded in half, shapes were painted in on the right-hand side and transferred by folding and pressing down, to the left-hand side. The design should be built up slowly, offsetting each shape on to the other side before continuing with the next.

22 *(above)* *Dripped paint*

23 *(below)* *Dripped paint*

24 *Blot design*

25 *Using pure shapes*

26

2 Black and white

Black and white abstract designs can be most effective. In many of the examples that follow, alternate areas have been coloured in black, and these shapes therefore form a sharp contrast with the white areas that are left. All shapes are equally important in the complete design and must be considered in relation to each other— a black shape, for example, must relate to the white space surrounding it. In most cases the total effect will rely on precision, both in design and painting.

Supports such as white card, primed hardboard (fibreboard or composition board), or canvas are the most suitable for this type of work.

The scale of the work may depend upon the technique being employed, the intricacy of the design, and the effect required. On the whole, large scale work is desirable.

Many types of black paint are available and one should experiment with a variety of these. With some designs the use of several types of paint will give very exciting results. For most work a matt paint is required and black emulsion or matt blackboard paint will therefore be most suitable for painting on hardboard, whilst poster paint or black ink will suit work on card. It is important that the paint flows easily; in some cases it may need thinning. A number of brushes are needed; their selection will depend upon the type of work to be done. Good quality flat or angled brushes are best for long, straight edges,

and fine, pointed brushes will get into points and corners.

In some instances, the white parts of the design may also need painting in. If this is so a matt white paint will usually be required. In the case of hardboard, several primings with white paint should suffice. Each coat of paint should be applied in a different direction, using a large, soft brush. If good quality card is used, the white areas may be left the colour of the card.

Care with the painting is essential; a good design can so easily be spoilt by poor application of paint.

Of course, other colours could be substituted for black and white. It is important that a strong contrast of colour is achieved—the use of complementary colours for example.

Pure shapes

Very exciting paintings may be composed by contrasting black geometrical shapes against a white background or, alternatively, white shapes against a black background.

Figure 25 is an extension of this idea: some of the larger black shapes have been broken up by the use of 'negative' white shapes.

A design can also be made from overlapping geometrical shapes. See also *figures 1 and 2*, pages 8 and 10.

Positive and negative

Shapes which are dissected by a line may form the basis of a positive/negative design.

In *figure 26* a semi-circle dissects the black lines. Shapes beneath the arc are left white and the spaces between them are painted black—the opposite to those above. The idea offers almost unlimited possibilities.

Shape expansion

Interesting results are possible from the repetition and expansion of a simple shape. In this way, parts of the design become exaggerated and add to the interest of the work.

Figure 27 shows how a line with a simple kink in it develops into a design which is visually most exciting. The thickness of lines and spaces has been varied to add further contrast to the design.

In *figure 28* the expansion of a circle makes a very powerful abstract design.

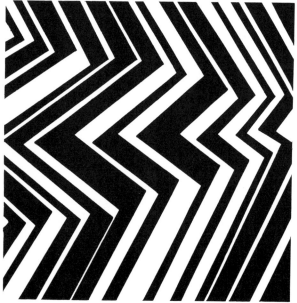

26 *(above)* *Positive/negative design*

27 *(below)* *Shape expansion*

28

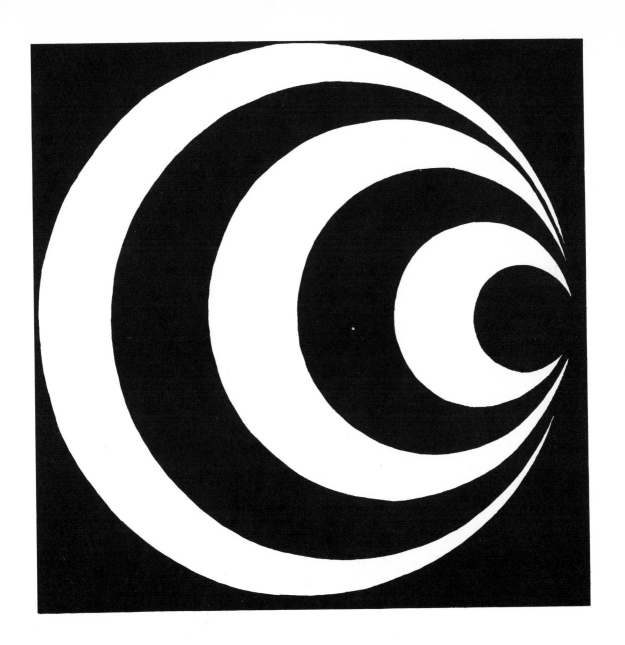

28 *Expansion of a circle*

Overlapping shapes

Designs of this type are made either by repeating an individual shape (or shapes) so that it overlaps those already drawn, or by drawing lines so as to cut across existing lines, thus causing a variety of shapes to be formed. Alternate areas are then painted black.

Possibly the most effective paintings of this type are those worked out on a mathematical basis.

Figure 29 was constructed from three sets of lines: from the top left-hand corner lines were drawn to points equally spaced on the bottom edge, excluding the bottom right-hand corner; likewise lines were drawn from the bottom right-hand corner to similar points on the top edge; and lines were also drawn to link points on upper and lower edges. An interesting set of shapes resulted. There is an illusion here of a series of superimposed triangles.

Many variations are possible. See also *figures 8 and 9*, page 14.

Shapes built from a common baseline

In *figure 30* the design has been developed from shapes built up from three baselines.

Shapes can be drawn either side of the baseline or simply keeping to the left, right, top or bottom of it. Likewise one baseline can be used or several. As in the example, shapes drawn from the baseline can be subdivided.

Designing from the centre

Figure 31 is based on lines drawn either side of the centre which have been repeated at various intervals. Alternate spaces are painted black.

Similar designs can be made with a compass or by the expansion of a regular shape. Variations can also be achieved by working from the edges inwards. See also *figures 7 and 24*, pages 13 and 25.

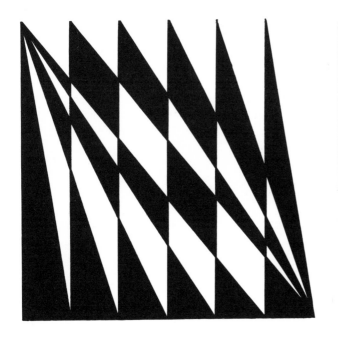

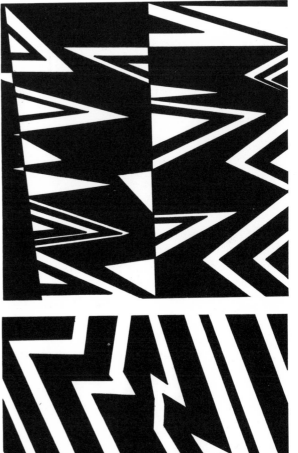

29 *(above left)* *Design from shapes caused by overlapping lines*

30 *(above right)* *Designing from baselines*

31 *(below right)* *Designing from the centre*

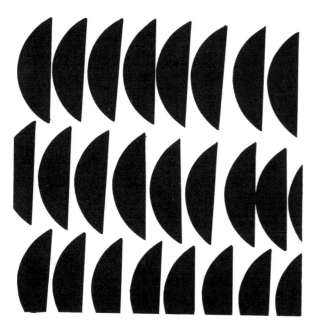

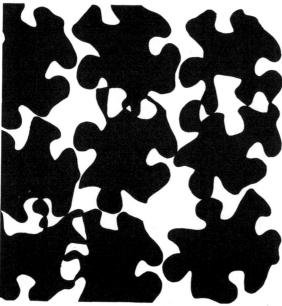

Shape repetition

A later section of this book is devoted to pictures which can be composed by repeating a single shape in different ways. Many of these methods may be applied to black and white designs.

In *figure 32* a segment has been repeated. Such designs can be made interesting in a number of ways. In the illustration the gaps between the segments have been varied. This, and the use of part-segments, makes the painting visually more interesting. See also *figure 3*, page 11.

Using templates

A later section of this book describes more fully the use of templates for composing pictures.

Various 'found' shapes can be used to draw round, or shapes can be cut from strong card or other materials. The design can be composed of isolated shapes or from those which have been allowed to overlap.

In *figure 33* a large piece of a jigsaw puzzle has been used as the template. Some parts overlap.

See also *figures 3, and 11*, pages 11 and 16.

Optical designs

'Op' designs should promote purely visual excitement. The brain automatically makes various deductions about what is seen and these responses can be exploited by the artist. Optical pictures usually rely for their effect on contrasts of spacing or colour, or perhaps both.

In the example, *figure 34*, there is a pulsating contrast between the two solid black areas and the many smaller ones which surround them.

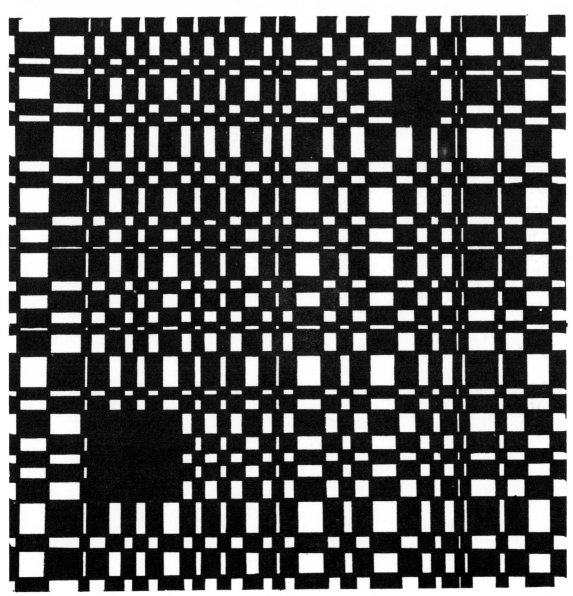

32 *(above)* *Shape repetition*

◄ 33 *(below)* *Using a template* 34 *'Op' design*

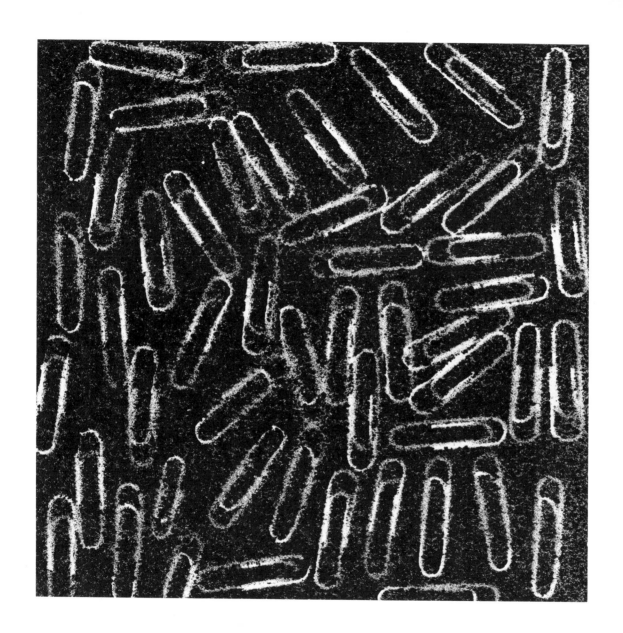

35 *Spray design*

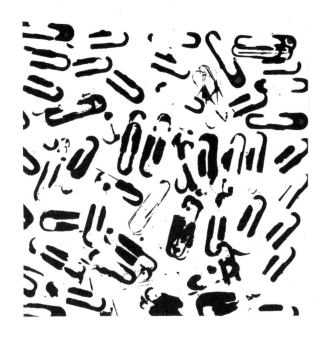

Spray designs

Spray designs can be made by using aerosol cans of paint, a spray-gun or spray diffuser such as water sprayers available from gardening suppliers and florists. Various parts of the picture surface are masked out before the application of the paint. In *figure 35* paper clips were arranged on the paper prior to spraying.

Other spray techniques are described in the section on templates.

Offset designs

Fascinating results can be achieved by dipping various objects in paint and offsetting them on to paper. Some thick paint is required and a pair of tweezers or pliers.

Paper clips were again used in *figure 36*. They were immersed in a shallow tray of blackboard paint; tweezers were then used to lift them out of the tray and press them gently in place on the paper. Cartridge (drawing) paper is ideal as it is absorbent to some extent and thus the paint does not run. Other commonplace objects can be used in this way with surprising effectiveness, especially in black and white.

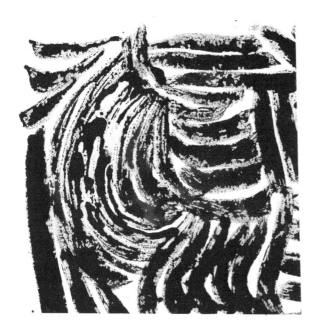

Free expression

Various techniques for free expression have already been described (see *figures 13 to 24*, pages 17 to 25).

Here again, many variations are possible and one can exploit various textures, paints, painting tools and so on. By using just black and white, good, bold designs should be possible.

Figure 37 explores the use of turpentine substitute and black poster paint. The brush was first dipped in the turpentine then in the poster paint. Interesting textures result.

A powerful, visual effect is achieved in *figure 38*. Here the paint is applied straight from the tube. Acrylic paint was used, the tube being held vertically and stamped down in various places on the paper.

In *figure 39* acrylic paint was used and applied with various lengths of card.

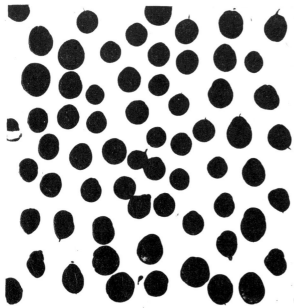

37 *(above)* *Free expression : paint and turpentine substitute*

38 *(below)* *Free expression : paint applied direct from the tube*

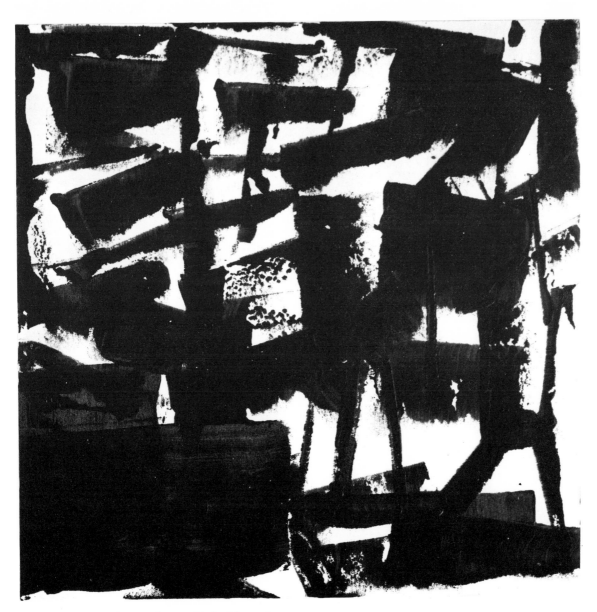

39 *Free expression : paint applied with various
lengths of card*

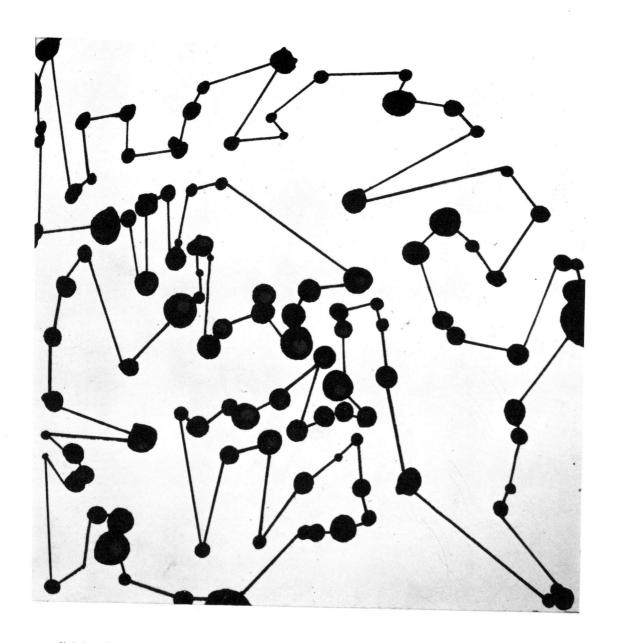

40 *Joining dots*

3 Drawings

Many drawing techniques may be suitably employed in an abstract interpretation. The examples on the following pages serve to illustrate different techniques and ideas, and may stimulate others. They should be regarded as starting points rather than conclusions.

As well as exploring ideas and techniques it is hoped that the reader will experiment with various media. Imaginative use of media can give most exciting results. Drawing implements such as pencils, charcoal pencils, crayons, ballpoints, felt-tips, pens and brushes can be used, as well as charcoal, chalk, wax crayons and ink. Various effects can be produced by using a combination of these different media.

Drawings will normally be done on good quality paper or card and be on a small scale. The paper or card could be coloured.

Joining dots

Dots placed at random or worked out at definite intervals can make an exciting foundation to a drawing. In *figure 40* the dots are blobs of ink which have been dripped on to the paper in various places. Size and spacing have been varied and this in turn gives lines of different length and direction when the dots are joined. In this example the dots are joined so as to form a continuous line. The lines must be drawn carefully and a straight-edge or ruler should be used.

Figure 41 also consists of random dots. Each dot is joined to two focal points, giving a most interesting result.

In *figure 42* the dots are placed at regular intervals around the outer edge. Again each dot is linked to two focal points.

Figure 43 consists of an arrangement of arcs. Each of the ends of the arcs has then been linked by a straight line to a common point.

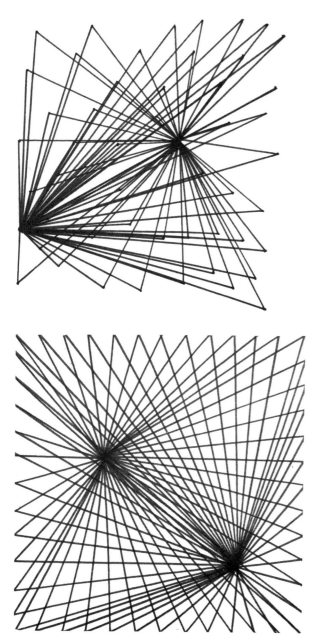

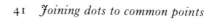

42 *Joining dots to common points*

40

43　*Arcs joined to a common point*

Superimposed shapes

Interesting drawings are achieved by overlapping shapes. The same shape can be repeated and overlapped on itself or different shapes can be used. A template can be used or the shapes freely drawn. *Figure 44* shows the use of a segment-shaped template and a combination of media. The drawing was done with ink and some of the overlapped parts shaded in with pencil.

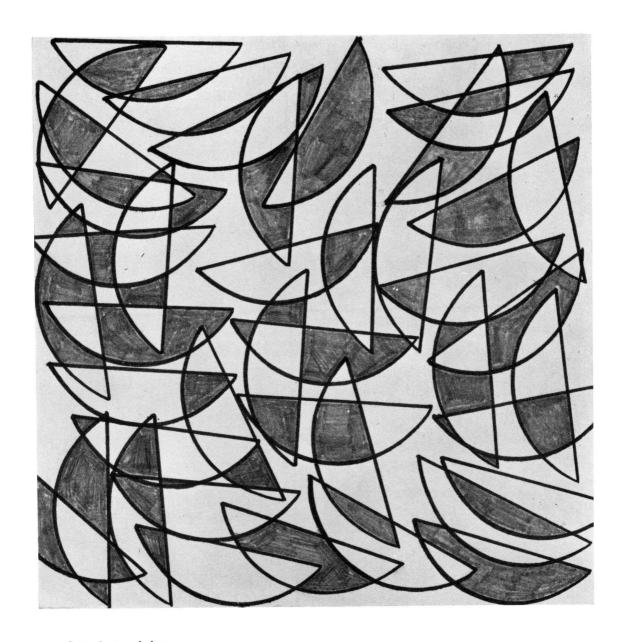

44 *Superimposed shapes*

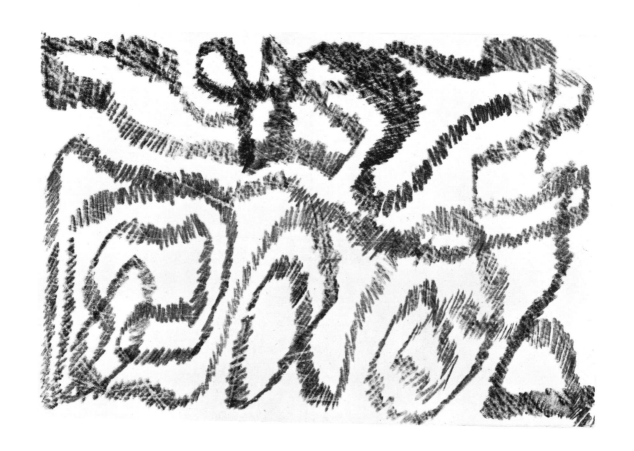

Using line—continuous line drawings

Figures 45–49 show various ways of using a single, continuous line.

Figure 45 was drawn with a charcoal pencil. As with the other examples of this type, the pencil was not removed until the design had been completed. Added interest has been achieved by varying the thickness of the line and by subtle changes of tone.

45 *Continuous line drawing*

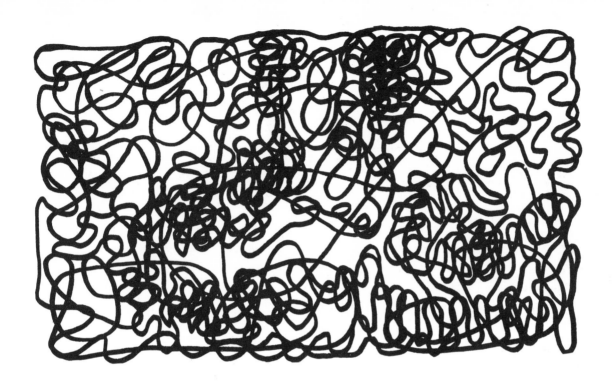

Figure 46 is more or less a scribble drawing. Again it is a continuous line with contrast achieved this time by intensifying the scribble in some areas whilst others are more open.

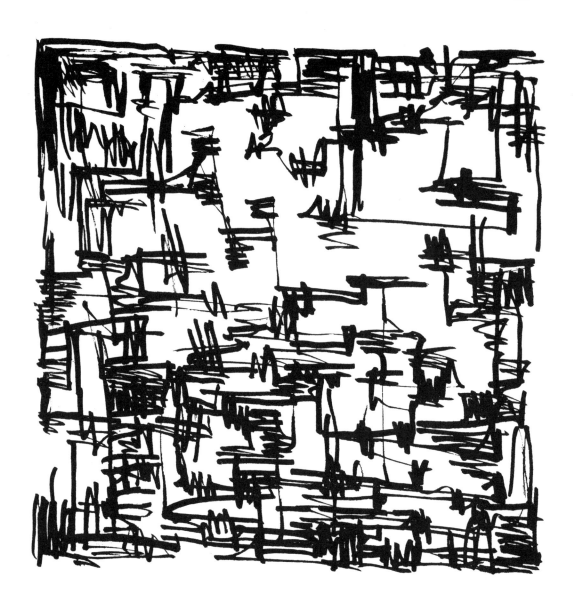

47 *Continuous line : pen and ink*

46

Figure 47 was drawn with pen and ink and is continuous in the sense that the pen worked its way around the paper from top left to bottom right.

Figure 48 is likewise based on a freely-drawn continuous line but this time with a more disciplined approach. Spacing and intricacy of line have again afforded contrast to the design. 'Maze' drawings are done in this way.

Paul Klee's famous saying that drawing is 'taking a line for a walk' certainly applies to *figure 49*. This drawing was made with the eyes closed. In such examples one becomes more conscious of movement, direction and rhythm of line; the results are often all the more interesting.

48 *(above)* *Continuous line drawing*

49 *(below)* *Drawing with eyes closed*

47

Brush drawings

Various types of drawings are possible with brush and ink.

The use of different brushes and several colours will give much variety to this kind of work. Brush and ink is particularly suitable for the more expressive type of design.

A flat brush has been used in *figure 50*, the qualities of the brush being exploited in the design.

Plate 1
Painting, abstract expressionism

50 *Brush drawing*

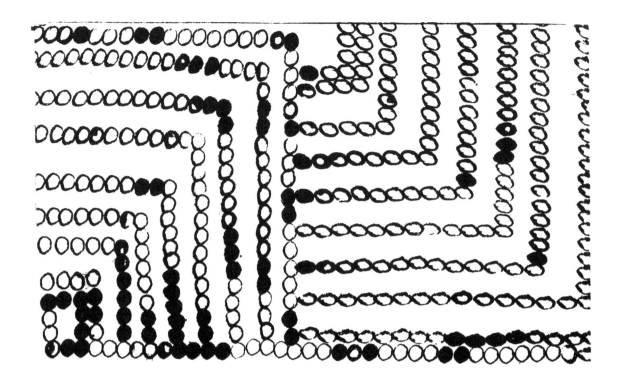

Impressed designs

Other objects may be used as drawing tools. In *figure 51* a drinking-straw has been used. This was first dipped into some ink and then pressed on to the paper. Several images may be made before it becomes necessary to dip the drinking-straw into the ink again. One should exploit the natural qualities of the materials being used. Here, there is a good, natural contrast between the full shapes and weaker ones, and this adds to the interest of the completed design.

51 *Impressed design*

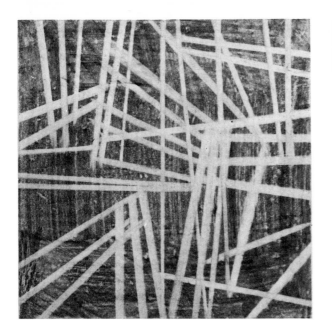

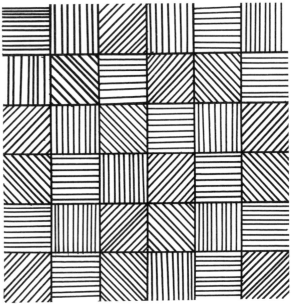

Using an eraser

Figure 52 shows the use of a pencil rubber to make a drawing. The whole of the paper was first shaded in with soft pencil. If the pencil is first applied in one direction, then in the opposite one, an even coating will result. The lines were then rubbed out, using an eraser against a ruler. It may be necessary to clean the rubber occasionally by rubbing it on some scrap paper. A protractor may be used to give curved lines or a freer method may be employed.

Hatching

Hatching may be done freely or with the aid of a ruler. In *figure 53* the paper was divided into squares and each square then had lines drawn in it of a different direction to those in adjacent squares. A ruler was used. An exciting contrast results between lines and spaces.

52 *Erased design*

53 *Hatching*

Designing around random shapes

Interesting drawings result when lines are interrupted by random shapes. First the shapes are drawn, and then lines are drawn across the paper. Where the lines meet a shape they are made to follow round it before continuing. Any deformities in the lines are thus exaggerated and create very exciting results. The lines may be drawn horizontally, vertically or at an angle. The random shapes need only be small and the drawing can be done free-hand or with the aid of a straight-edge or compass. *Figure 54* is an example.

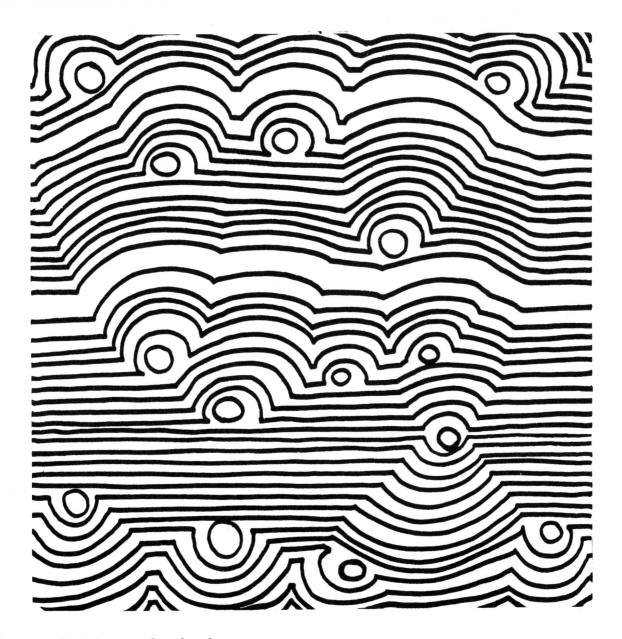

54 *Designing around random shapes*

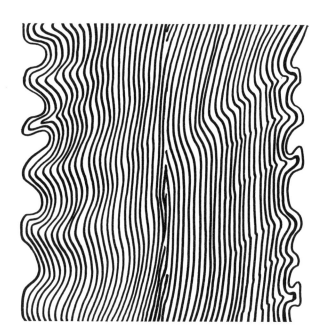

Designing from the centre

Designs which are based on the repetition of lines either side of the centre have already been mentioned (see *figures 7 and 31*, pages 13 and 31). These may be adapted to drawings.

Similarly, lines drawn along opposite edges may be repeated inwards to the centre, as in *figure 55*.

Figure 56 is an alternative version. Lines are repeated either side of a line drawn about one-third of the way across the paper.

55 *Designing from the edges inwards*

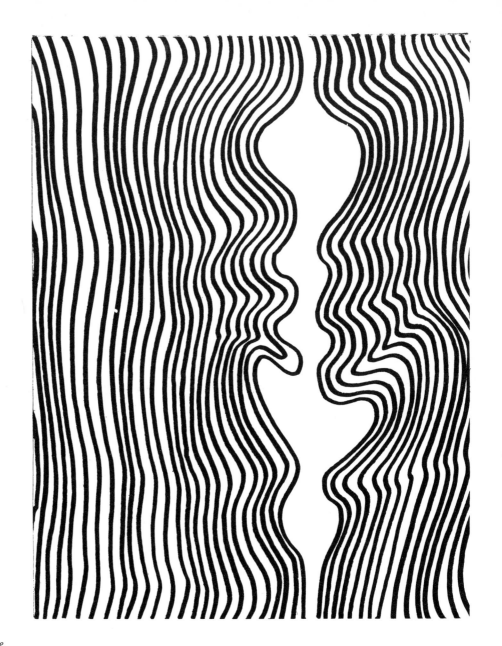

56 *Designing from a line*

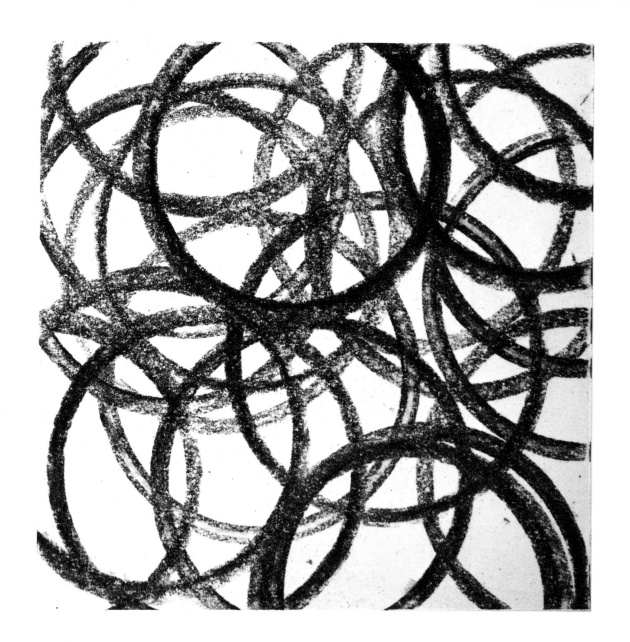

57 *Drawing with a compass*

56

Using a compass

As well as the straightforward use of the compass to create designs it can be used in conjunction with other techniques such as wax-resist, templates, and over textures. Also one must remember that the pencil is not the only drawing implement that will fit into a compass, so experiments can be made using other drawing tools and media.

In *figure 57* a thick stick of willow or vine charcoal has been inserted in the compass and a design built up accordingly. Here, one could create alternatives by varying the thickness of the charcoal and the size of the circles. Also, circles of a different size and in a different media might be superimposed over those drawn in charcoal. *Figure 58* shows a variation of this.

In *figure 59* the circles were drawn with white chalk on black paper. The thick lines were superimposed and were made by using the chalk on its side against a ruler. It is an interesting variation showing the use of white on black, an idea that could be used with regard to many other techniques.

Pencils, coloured pencils, charcoal pencils, chalk, ballpoints, felt-tips and wax crayons are among other drawing media which will fit into a compass.

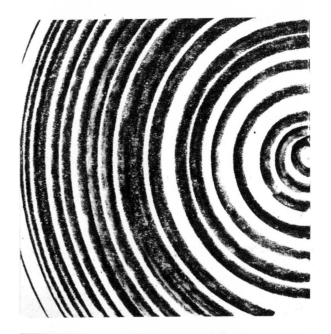

58 *(above)* *Drawing with a compass*

59 *(below)* *Chalk drawing*

Using texture

Interesting rubbings can be taken using wax crayons, Conté or chalk. Cartridge (drawing) paper is generally the most useful, but thinner quality paper such as newsprint can be used if the texture is shallow or elaborate. Coloured paper could be used or coloured chalk on white paper. Various textures could be superimposed in different colours and an abstract design formed in this way. The texture can form a design in its own right or the texture used as a background for other drawing.

Figure 60 is a rubbing taken in Conté on cartridge (drawing) paper of an arrangement of paper-clips.

Figure 61 is a rubbing of frosted glass. When taking a rubbing the paper is placed over the textured surface and held firmly in place whilst the crayon is rubbed systematically across it. The crayon is used on its side. It is usually best to rub the crayon across in one direction, eg left to right, and then in the opposite direction, eg top to bottom. With deep textures one must take care not to tear the paper.

60 *Conté rubbing of paper clips*

61 *Texture drawing : rubbing of frosted glass*

62 *Using a paper strip as an edge stencil*

Edge stencils

A thin strip of paper can be used as an edge-stencil or mask when drawing. The paper may have shapes cut from it.

In *figure 62* the triangular shapes were built up by using a thin strip of paper as an edge-stencil. The strip was placed in position on the paper and pen lines drawn down one edge of it for a desired length. The pen lines begin on the strip and are made to overlap for about 5 mm ($\frac{1}{4}$ in.) on to the paper beneath. The pen strokes should be quite close together, and will result in a very interesting broken line. The paper strip is then removed and placed in other positions, and the triangular shapes built up in this way.

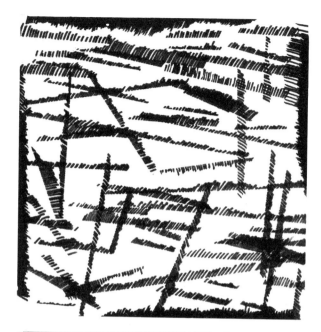

Figure 63 was composed in a similar way to *figure 62*. In *figure 64* a cut-out edge-stencil has been used. Again the design is formed by letting the pen or pencil run off the edge. In this example the stencil has also been used in reverse with a combination of pencil and ink lines.

Figures 65 and *67* show the use of strips of paper to mask out sections of continuous lines.

In *figure 66* the paper was first folded into eight equal strips. During the drawing the paper was folded back in various ways so that certain parts were masked out.

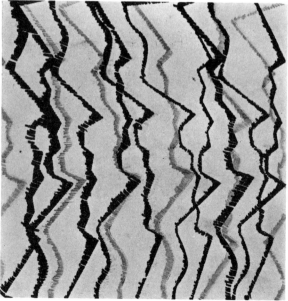

63 *(above)* *Drawing with an edge stencil*

64 *(below)* *Edge-stencil design*

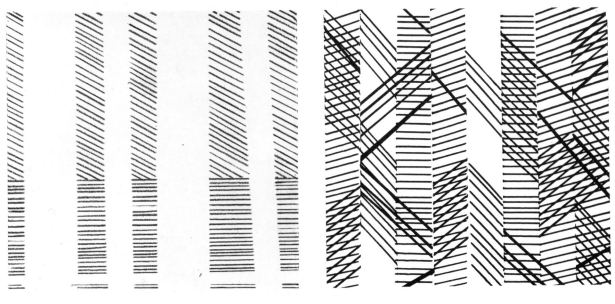

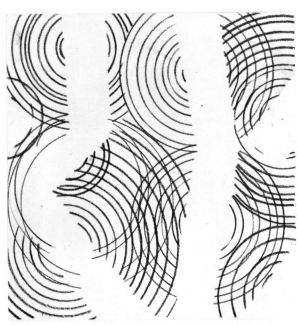

65 *(above left)* *Using a paper strip to mask out areas*

66 *(above right)* *Folding and masking*

67 *(below right)* *Compass drawing with masked areas*

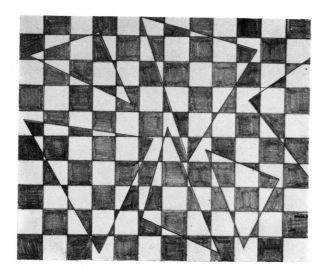

Mosaic drawings

Mosaic drawings must be done on small sheets of paper or card; their total effect depends upon neat, accurate work. The drawings may be executed in pencil or in a combination of media. The paper is first divided up into squares. Lines or shapes are then drawn over the squares so that they are dissected in various ways. Areas are then shaded in so that they are not bordered by an area of the same colour or medium. Where a square becomes subdivided, each part is filled in differently.

In *figure 68* various triangles were superimposed on the squares. An almost three-dimensional effect is realised.

Figure 69 consists of a continuous line drawn across the squares.

68 *Mosaic drawing*

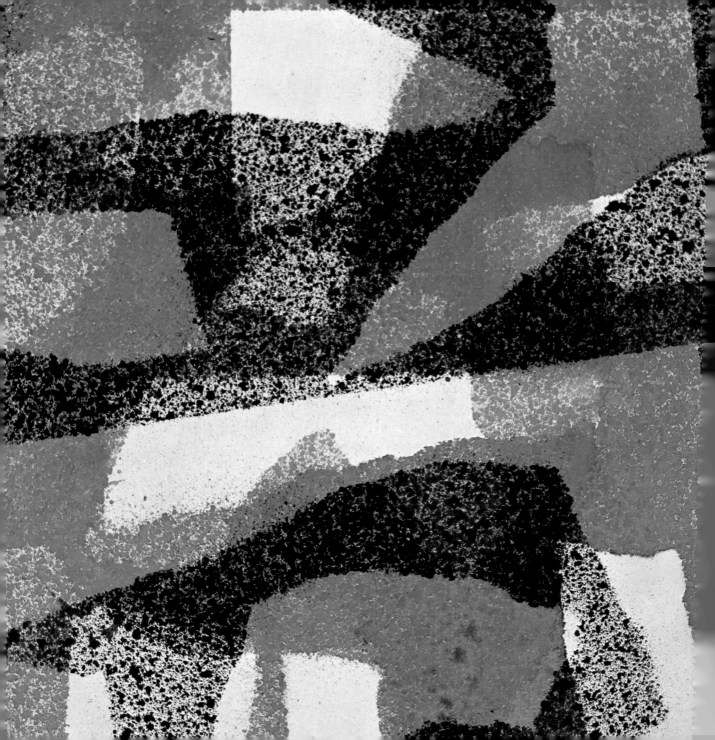

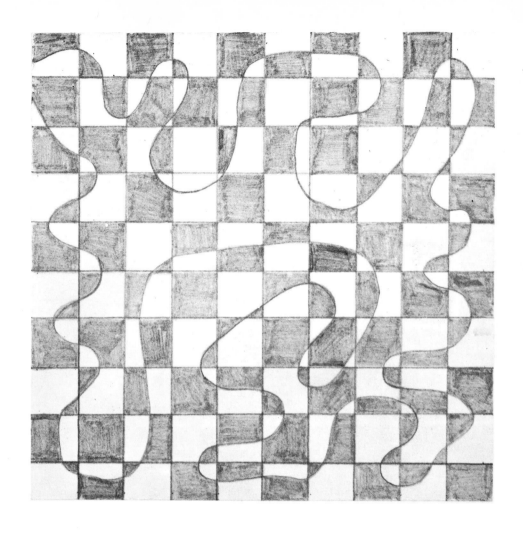

69 *Mosaic drawing with a continuous line*

Plate 2
Spray painting, masking with torn paper

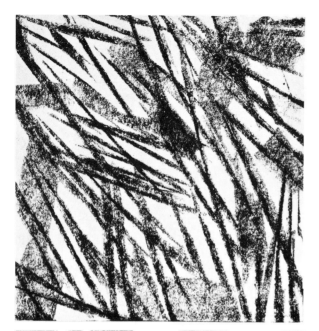

Drawings with chalk and crayon

There are various ways in which chalk, wax-crayon, Conté or pastel crayons can be used to produce interesting drawings. Again one should exploit the various characteristics of the medium being used. Several possibilities for exploration are suggested on the following pages.

Figure 70 shows Conté crayon used on its side. Note the contrasts of the line and texture.

In *figure* 71 various lengths of Conté have been used to build up a very striking design.

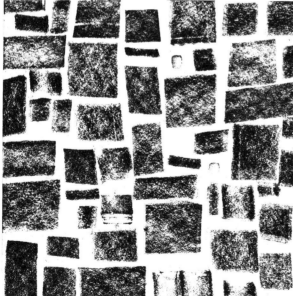

70 *(above)* *Conté drawing*

71 *(below)* *Conté drawing*

In *figure 72* a short length of crayon has had a small v-shaped cut made in one of its sides. When used on this side it therefore produces two lines. The design has been built up in this way, making use of contrasts in length, direction and spacing.

Figure 73 illustrates the use of a wax crayon which has had several cuts made along one side.

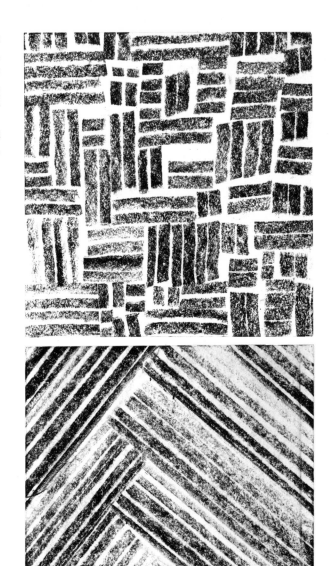

72 *(above)* Conté *drawing*

73 *(below)* *Using an indented stick of wax*

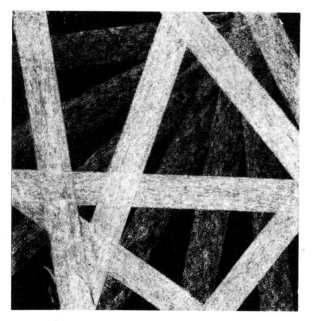

In *figure 74* the Conté crayon was held vertically and pressed down in desired places on the paper.

Figure 75 shows white chalk on black paper. A length of chalk was used against a ruler.

Figure 76 illustrates square sticks of Conté which have been rolled in various directions combining with charcoal used in a similar way.

74 *(above)* *Stick of Conté used vertically*

75 *(below)* *Chalk drawing*

76 *Rolled Conté and charcoal*

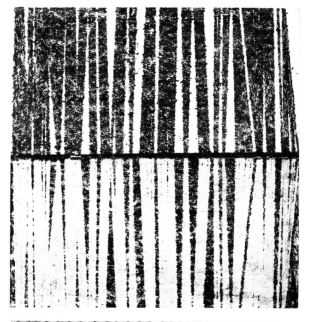

Chalk and wax

Interesting positive/negative designs can be achieved by using chalk and wax. The paper is first folded in half. The right-hand half is coated with a layer of white chalk, then with one of wax. A coloured wax crayon may be used. It is important that the chalk covers all parts of the paper so that no gaps are left. The paper is then folded over, and the design drawn so that one is pressing down on to the wax coating underneath. Any drawing instrument which will give a firm impression may be used: pencils and ballpoint pens are usually the most suitable. When the paper is opened out one will find that the drawn parts have offset on to the left-hand side of the fold with a positive/negative result. *Figure 77* is an example.

In *figure 78* chalk and charcoal were used in exactly the same manner.

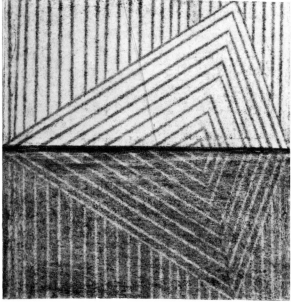

77 *(above)* *Chalk and wax*

78 *(below)* *Chalk and charcoal*

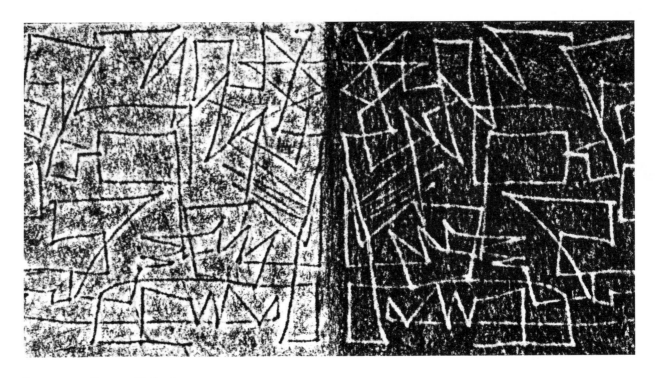

Impressed pencil designs

Figure 79 consists of a pencil impression which has been coated with Conté crayon. The paper was folded and the design drawn in, pressing down heavily so as to create an impression on the paper beneath. The paper was then opened out and shaded over with Conté crayon applied in a similar way, as if taking a rubbing (see *figure 61*, page 59). On the right-hand side the lines will have been indented and thus the crayon will go over them, leaving them white against a coloured background. On the left-hand side the lines are slightly raised and thus attract a heavier coating of crayon than the background.

Impressions may also be taken off paper coated with Conté, wax, chalk, etc., or carbon paper.

79 *Impressed pencil design*

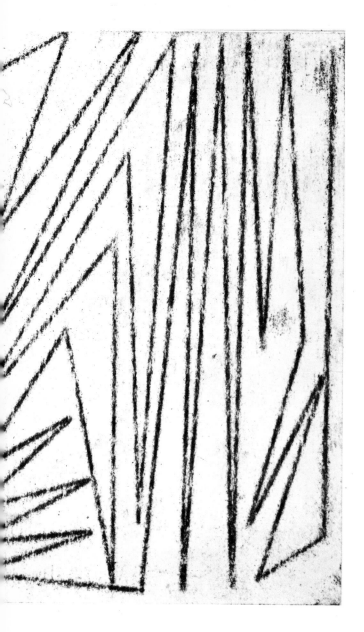

Figure 80 shows an impression taken off a Conté base. Here a small sheet of paper was coated heavily with Conté. A second piece of paper was laid to cover it and a drawing made. When the paper was removed the reverse side of the drawing consisted of an offset impression.

80 *Impression off a Conté base*

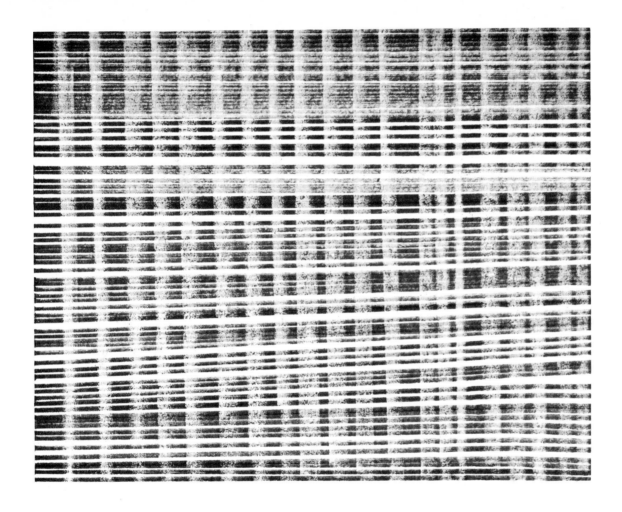

81 *Drawing with wax and felt-tip*

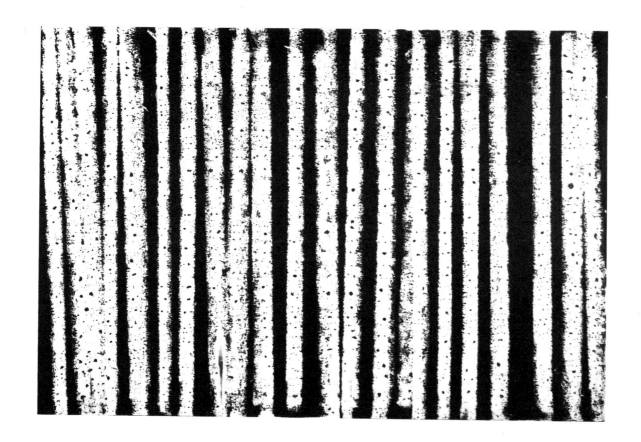

Wax resist

Exciting results are possible using wax in combination with ink, felt-tip pens or spray paint. If applied thickly the wax areas resist applications of ink or paint and thus interesting textures and contrasts result.

Wax etchings are made by first coating the paper with small, thick areas of wax crayon (black should not be used). The whole paper is then covered with indian ink until none of the wax shows. When this has dried lines and areas can be scratched away with a fine point or knife, revealing the wax colours beneath.

In *figure 81* wax lines contrast with those drawn in felt-tip. *Figure 82* shows a wax and ink wash. In both examples the wax crayon was used against a straight-edge.

82 *Wax resist drawing*

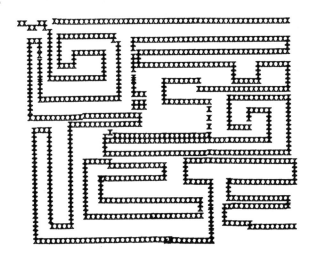

Typed designs

Quite remarkable results are possible with a typewriter. When repeated certain letters give vivid abstract designs. Again it is necessary to make use of the various qualities of the implement being used. On the typewriter, for example, move backwards, up and down, as well as across. Make use of different spacing and of capital and lower case letters.

In *figure 84* spacing has played the major role. Here the unit is repeated plus one each time, but the space between remains the same. This gives quite a powerful optical effect.

83 *Typed design*

84 *Typed design*

Duplicate images

Figures 85–87 show the use of several drawing instruments at once. Two, three, four or even more pencils, felt-tip pens or ballpoints may be held in the hand together and a drawing subsequently made. It is essential that they are held firmly. A combination of different drawing tools adds to the effect.

85 *(above)* *Duplicate image : two felt-tips*

86 *(below)* *Duplicate image : felt-tip pen and pencil*

87 *Duplicate image : ballpoint, two felt-tips*
and two pencils

Template A

Positive shape

Template B

Negative shape

4 Abstracts from templates

Templates are usually cut from thin card but there are a variety of other ways they can be made. Torn paper, paper-cut designs, transparent adhesive tape, string and 'found' objects are among other materials which might be used as templates. Various techniques involving their use are explained on the following pages.

The template can be used as a positive or a negative shape: it may be regarded as a unit of design or as a space between the main shapes of the design. Consequently the template can be a shape which is used to draw round or mask out areas in spray-painting or it may be a rectangle or square from which a shape has been cut out.

In *figure 88*, template A consists of a rectangle of card from which a triangular shape has been cut. If this is stippled or sprayed over it gives a positive shape, as shown. Template B acts as a mask and if this is sprayed over it produces a negative area. A sharp knife should be used to cut shapes from card. It is safer to use the knife against a straight-edge but this will depend upon the shapes required.

Paintings

Paintings may be designed wholly or partially with the aid of a template or templates. The template is drawn round in desired positions on the hardboard, canvas, or other support being used. Shapes are then carefully filled in with the colour required. The design could consist of a repetition of one shape, be composed from two or more templates, or rely on superimposed shapes.

In *figure 89* a single trapezium-shaped template was used and made to overlap on itself. See also *figures 3, 32*, pages 11 and 32, and the section on unit repetition.

Drawings

Again a shape is used to draw round in various positions on the paper. The template may be cut from card, or some other suitable small object may be used instead. Many variations of design are possible even with a single template. Lines can be overlapped, and parts shaded in. A combination of different media can be used. In the case of a template cut from card, it can be turned over and used in reverse as well.

The template in *figure 90* was made from a strip of card which had shapes cut from one edge. This edge was used to draw along and results in a line which is repeated down the sheet of paper. The spaces between these lines become interesting, and Conté and pencil was used to fill in some of the shapes thus formed. See also *figure 44*, page 43.

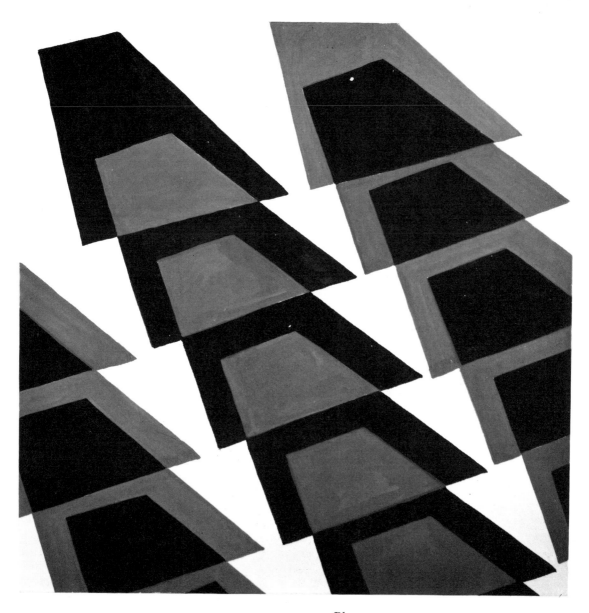

89 *Painting using a template*

Plate 3
Assembled picture, dividing and rearranging

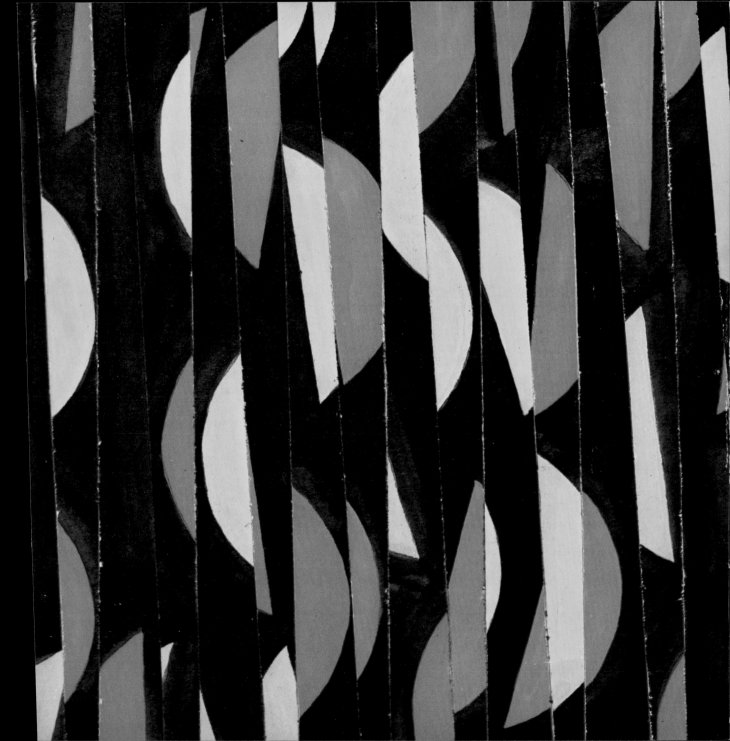

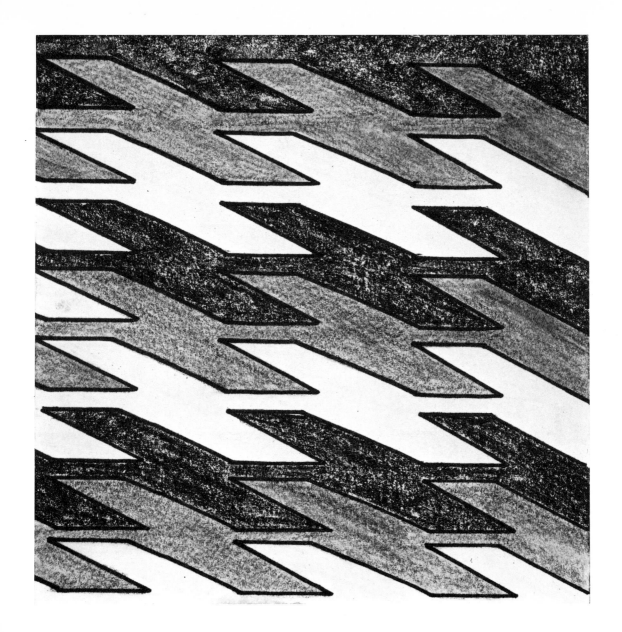

90 *Drawing using a template*

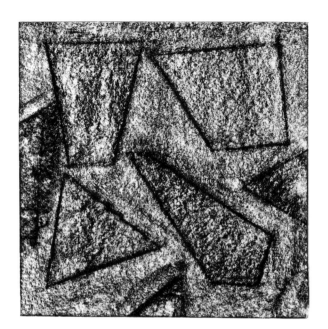

Rubbings from templates

Interesting results may be obtained by using the templates under the sheet of paper and taking a rubbing or impression from them. *Figure 91* is an example of such a rubbing. It is taken with Conté crayon from card shapes. See also *figures 60* and *122*, pages 58 and 107.

Stippling

Templates may also be used to stipple around. A stippling brush is ideal for this but a large stiff-haired painting brush will suffice, eg a No. 10 bristle. The brush is held vertically and dabbed along the edge of the template. The brush should be fairly dry; if it is loaded heavily with paint it is likely that paint will seep under the edges of the template and spoil the effect.

Designs can be built up by superimposing shapes in different colours or by creating a positive/negative effect with stippled out background. Edge-stencils may be used in a similar way (see *figures 62, 63* and *64*, pages 60 and 62).

In *figure 93* the white shapes contrast against a stippled out background. Other stippled edge-shapes were then superimposed.

91 *Rubbing from templates*

92 *Stippled design*

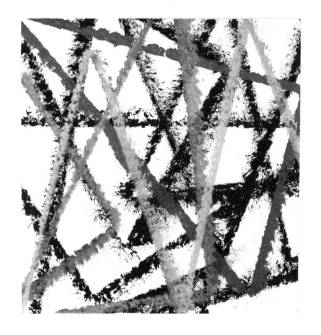

93 *Stippled design with stippled out shapes and edge shapes*

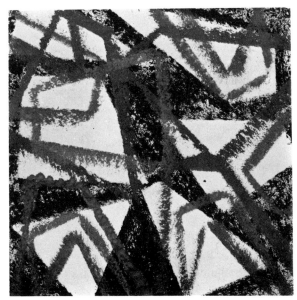

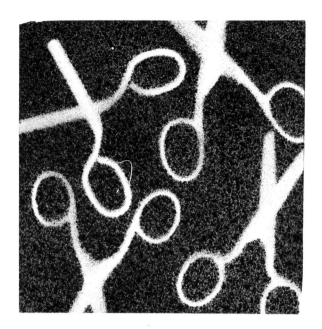

Masking out

Various materials may be used to mask out areas of the paper or support prior to spraying. Suitable materials include torn or cut paper shapes, paper-cut designs, hessian (burlap), transparent adhesive tape and string. Quite complex designs may be built up by applying several colours and overlapping other shapes, or using shapes in a different sequence. It is important that each coating of paint is allowed to dry before the next is applied; it is also advisable to leave the shapes being used to mask areas in position until they have dried. This will prevent smudging. Thin layers of paint should be applied, and the support propped up at a slight angle.

Aerosol cans of paint, a spray-gun or spray diffuser can be used to apply paint. In the case of a spray diffuser it is essential that paint of a thin consistency is used so as not to clog the diffuser.

If the material being used to mask areas is of a lightweight quality then it will have to be attached in some way to the support to prevent it moving under the pressure from the spray paint. Thin paper or newsprint can sometimes be 'wetted' on to hardboard, fibreboard, composition board or canvas, otherwise drawing pins (thumb tacks) paper clips or transparent adhesive tape can be used to fix shapes in position. When using paper, the sheet should be selected so as to allow for a border around the design; shapes can very often be attached to the border which can later be trimmed off.

As well as spraying, paint may be stippled or flicked on.

Objects as templates

'Found' objects may be used as templates. Items such as scissors, hands, protractors and combs, for example, can be used in this way. They are simply drawn round in various positions on the paper to form a design.

In *figure 94* four pairs of scissors were placed on the paper which was then sprayed, using poster paint and a spray-diffuser. See also *figures 11*, *33*, *35* and *36*, pages 16, 32, 34 and 35.

94 *Use of 'found' objects as templates*

Torn paper

Strips or shapes torn from paper are used to mask out areas before spraying. Newspaper is ideal for this purpose. *Figure 95* shows such a spray design using torn paper shapes.

Figure 96 illustrates a spray design from torn strips of newspaper. Three sprayings were made here, making use of two colours, overlapped areas, and using the strips of paper in two directions. Note that in this example there is a large amount of 'drift' where the spray has seeped under masked areas. Spray paint is very searching and masked areas must be attached firmly if a positive contrast is required. Often 'drift' may add to the effect of a picture and one can use it to give graduation of tone or merging of colour. See also *figures 65* and *67*, page 63.

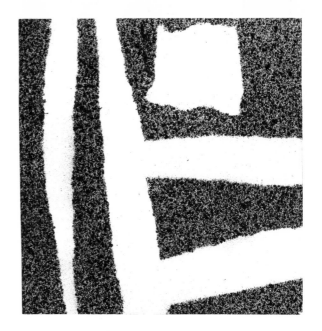

95　*Using torn paper to mask out areas*

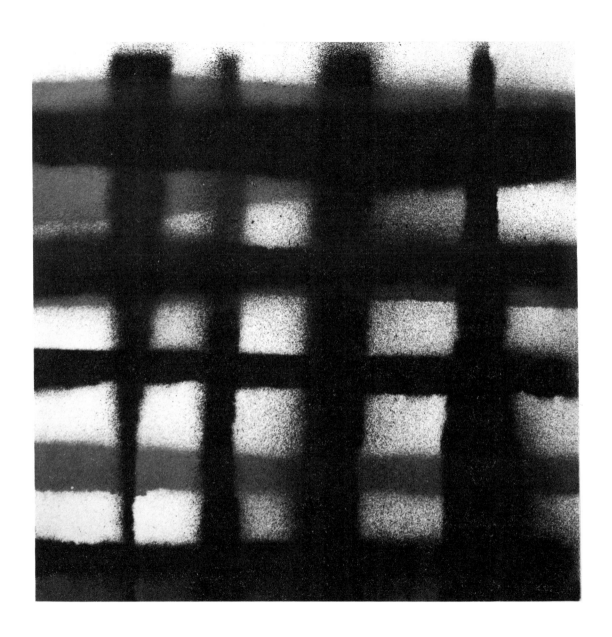

96 *Spray design with torn strips of newspaper*

Paper-cut designs

Designs cut from folded paper can be used to create interesting spray pictures. Shapes are cut from the fold, the paper then being opened out and used as a mask through which to spray. Shapes cut from the paper thus equate with the sprayed in areas of the design.

In *figure 97* the template was made from a sheet of paper which was first folded in half. Shapes were then cut on the fold, and the paper opened out and used as a mask through which spray paint was applied. A spray diffuser was used in this example, with thin poster paint. The design consists of two sprayings, the first with the mask placed horizontally and the second with it used vertically. Overlapped areas provide interesting contrasts of colour.

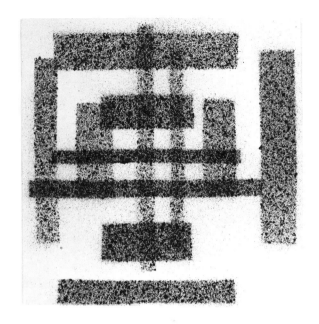

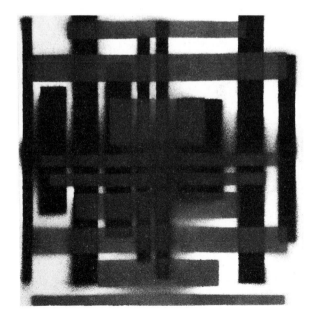

97 *(above)*　*Using a cut paper template*

98 *(below)*　*Spray design with paper-cut mask and using aerosol paint*

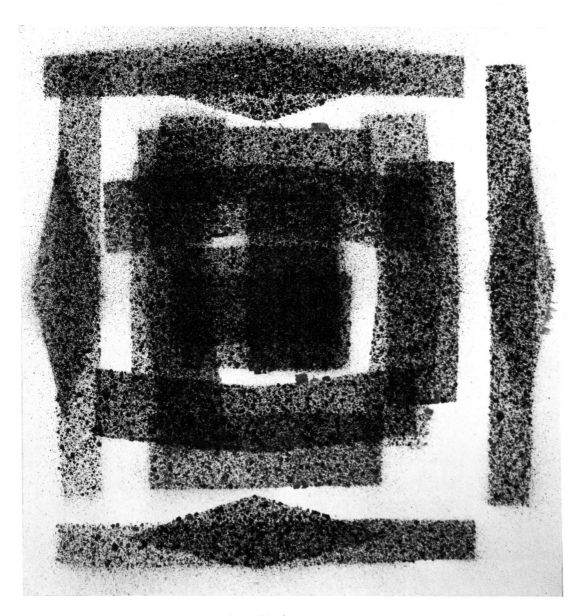

99 *Spray design with paper-cut mask used in four
positions*

88

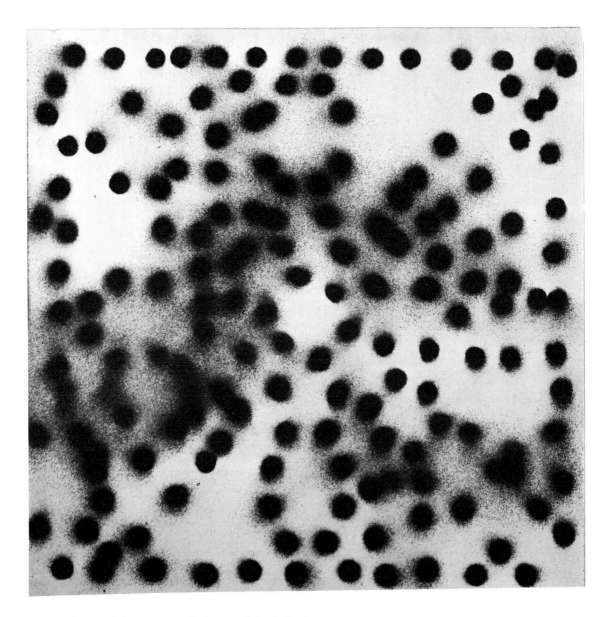

100　*The mask here was made by punching holes in a sheet of paper*

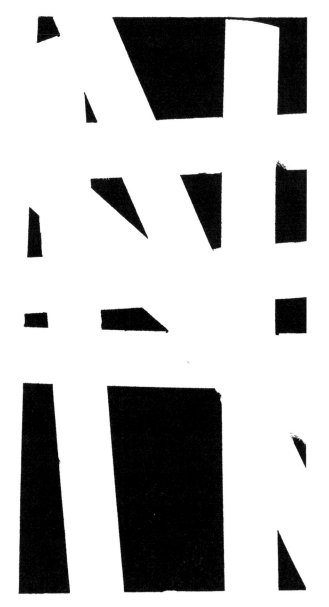

Using transparent adhesive tape

Lengths of *Sellotape* or *Scotch Tape* may be used to mask out areas on paper, canvas or hardboard. The texture of the support will determine whether or not *Sellotape* or *Scotch Tape* can be used and it is advisable to test this first of all. If the *Sellotape* or *Scotch Tape* is applied lightly to the surface it will generally lift off easily and without tearing.

Figure 101 shows the use of transparent adhesive tape strips on cartridge (drawing) paper using aerosol paint.

Usually the spray paint will dry quite quickly on the paper while remaining wet on the adhesive strips. In this case it is possible to take an impression from the lengths of tape by placing a sheet of paper over them and carefully rubbing it over. *Figure 102* shows such an impression, from strips of transparent adhesive tape. See also *figure 107*, page 96.

In *figure 103* the paper was first coated with wax (a white wax crayon was used). It was then sprayed, using aerosol paint. While the paint was still wet strips of transparent adhesive tape were used to offset it and thus create the textured lines running across the design. A second spraying was then given using torn strips of paper arranged vertically.

101 *Using transparent adhesive tape*

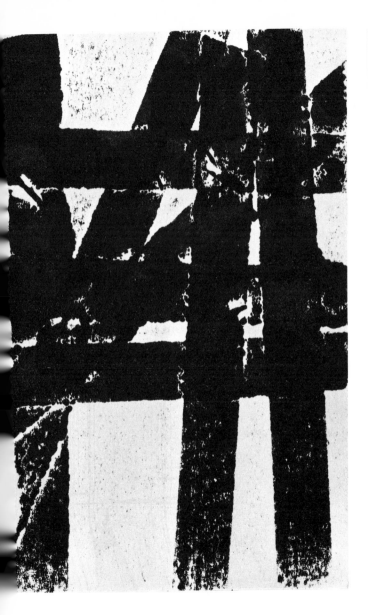

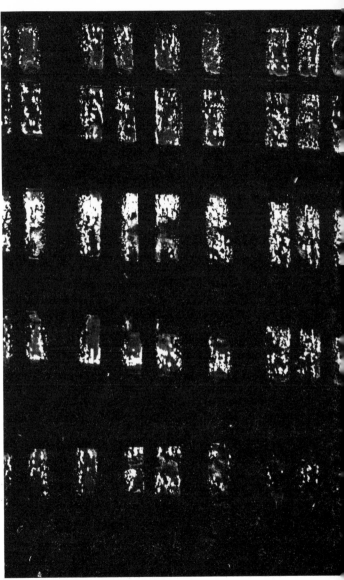

102 *Impression from strips of* Sellotape *or*
Scotch Tape

103 *Wax and spray paint*

String

Exciting abstract results are possible by using lengths of string to mask out whilst spraying. Different lengths and types of string can be used and a picture built up with several colours and various arrangements of string. Both string and paper must be dry before the positions of the lengths of string are changed.

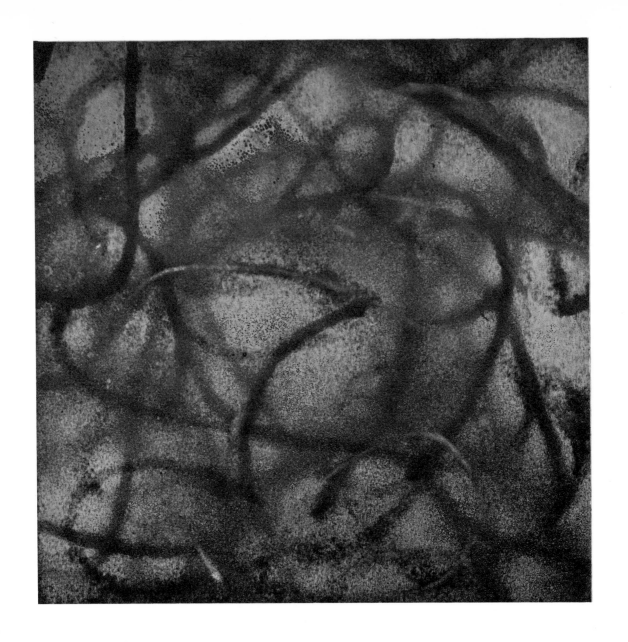

104 *Spray design using string*

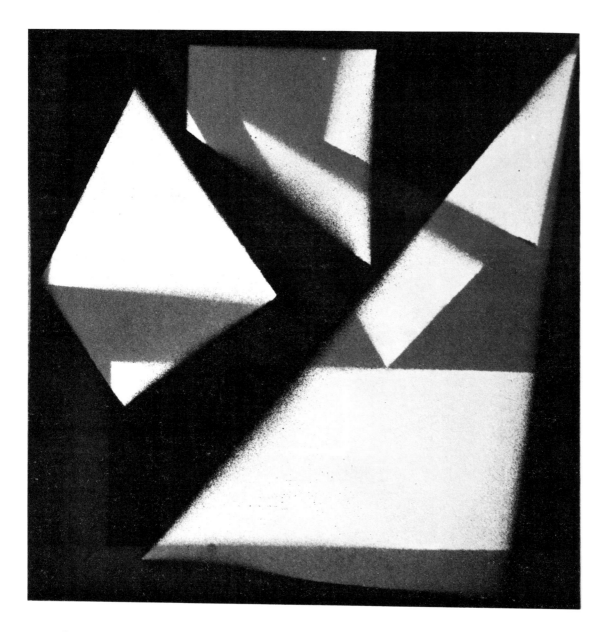

105 *Spray design with card templates*

Card templates and spray paint

Figures 105–108 illustrate various ideas involving shapes cut from thin card and aerosol paint.

Figure 105 shows three sprayings, making use of superimposed shapes.

In figure 106 a remnant of paper was used that had paint flicked on to it. Card templates were then used to mask out areas and build up the design.

Figure 107 shows how texture was gained by offsetting paint from lengths of transparent adhesive tape. (See also *figure 102*).

In *figure 108* a rubbing was first taken in Conté over some frosted glass. Areas were then masked out with card shapes prior to spraying.

Many variations are possible.

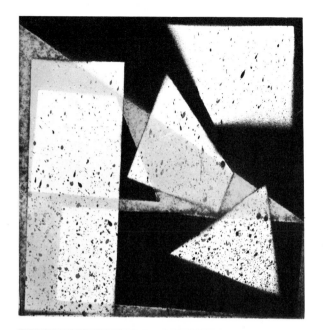

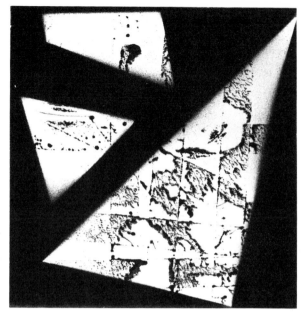

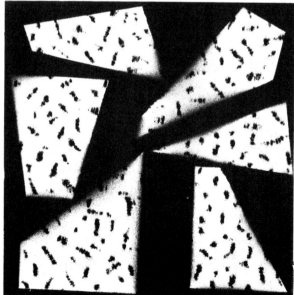

106 *(above left)* *Spray design with card templates*

107 *(above right)* *Spray design with card templates and offset* Sellotape *or* Scotch Tape *texture*

108 *(below left)* *Spray design incorporating card templates and texture*

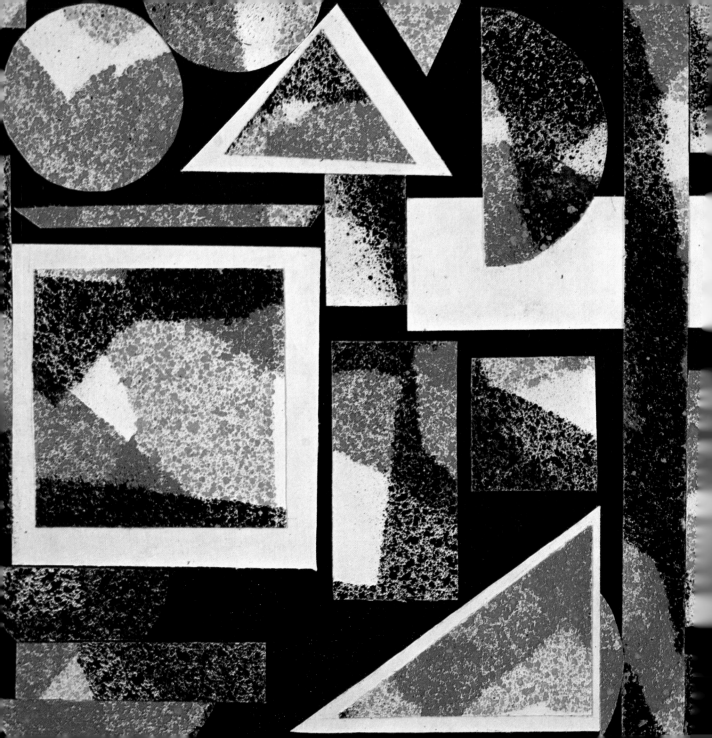

5 Unit repetition

The composition of some abstract pictures is dependent upon the repetition of a particular shape or shapes. Many of the techniques illustrated in this book may be applied to unit repetition and thus such pictures may use techniques involving painting, drawing, templates or cut shapes.

In composing pictures based on the repetition of a shape one must bear in mind that the spaces which surround the shapes are equally important. Added interest might come from the use of several colours, by varying the size of the unit, eg the use of different sized circles, by using more than one shape, by subdividing the shapes or by using texture.

The unit may be recreated in a number of ways: by using a compass, ruler or set-square (triangle), by a mathematical subdivision of the picture area, by using a card template, by using a 'ready-made' template, or by using cut-out shapes. Whether the shapes are painted, sprayed, or glued on, precision is essential.

The scale of the work will again depend on various factors, but large scale work is desirable.

As with other sections of the book, the illustrations serve to clearly express an idea or technique; in most cases expansion of the idea will be necessary to create a finished painting.

Plate 4
Building with cut out shapes

Methods of repeat

Figures 109–112 show four ways of repeating the same shape. *Figure 110* shows what is known as the 'brick' method of repeat and *figure 112* illustrates the 'half-drop'. Even with just one shape there are many ways it can be repeated. If one has not already explored methods of repeat in pattern making or potato printing, then one should be encouraged to do so now. In fact, potato printing could well be used as a preliminary exercise to larger paintings involving unit repetition. Some other possible ways of repeat are listed in diagrammatic form below.

1 Combining units the same way up, as:

Row 1	U	UR	U	UR		
Row 2	UR	U	UR	U		
Repeat						
Row 1	U	UR	UR	U	U	UR
Row 2	UR	U	U	UR	UR	U
Repeat						
Row 1	U	U	U	U		
Row 2	UR	UR	UR	UR		
Repeat						

2 Using units upside-down, as:

Row 1	UD	UDR	UD	UDR	
Row 2	UDR	UD	UDR	UD	
Repeat					
Row 1	UD	UDR	UDR	UD	UD
Row 2	UDR	UD	UD	UDR	UDR
Repeat					

3　Alternating units used upright and upside-down, as:

Row 1　UD　UR　UD　UR
Row 2　UR　UD　UR　UD
Repeat
Row 1　UDR　U　UDR　U
Row 2　U　UDR　U　UDR
Repeat

4　Alternating different units or colours, as:

Row 1　*1*　*2*　*1*　*2*
Row 2　*2*　*1*　*2*　*1*
Repeat

This could also involved the combination of upright and upside-down units.

5　Combining different rows, as:

Row 1	*Row 1*	*Row 1*	*Row 1*
Row 2	*Row 2*	*Row 1*	*Row 1*
Row 1	*Row 2*	*Row 2*	*Row 2*
Row 2	*Row 1*	*Row 2*	Repeat
Repeat	Repeat	Repeat	

U = Upright
UR = Upright Reversed
UD = Upside-down
UDR = Upside-down Reversed

The combinations listed above are by no means exhaustive; they do not take into account, for example, the use of 'brick' or 'half-drop' methods of repeat.

Of course, it is not essential to repeat the unit in one of these set ways—a freer interpretation is possible and may well be visually more exciting.

Figure 113 illustrates a simple repeat using a card template. The shape here was cut from card and drawn round in the appropriate positions, the shapes then being painted in. (See also *figures 32* and *129*, pages 32 and 111.)

109　*(above)*　*Method of repeat*

110　*(opposite above left)*　*'Brick' method of repeat*

111　*(opposite above right)*　*Method of repeat involving reversed units*

112　*(opposite below left)*　*'Half-drop' repeat*

113　*(opposite below right)*　*Simple repeat using a card template*

Using different colours

The use of colour to create variety within the repeated shapes has already been mentioned. In a straightforward repeat of the same shape, colour could play a vital role. The colour might align itself with the repeat or be used independently. *Figure 114* shows a repeat involving the same shape used upright and then upside-down alternatively. Four colours were used.

114 *Repeat design using four colours*

115 *Using combinations of shape, colour and texture*

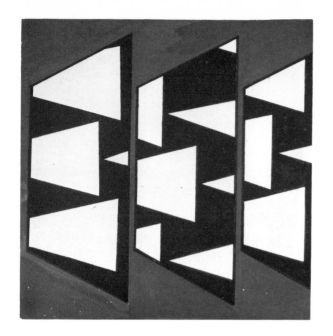

Divided shapes

Basic shapes can be subdivided by drawing in further lines or shapes.

In *figure 116* the basic shapes have been split up by the addition of triangles or part-triangular shapes, these being painted in a different colour. Note that the shapes being used to subdivide should relate to the main shape.

Figure 117 shows the division of a repeated unit by drawing lines across the design at regular intervals; the shapes thus formed have been coloured alternately.

116 *Subdivision of basic shapes*

117 *Division of repeat at regular intervals*

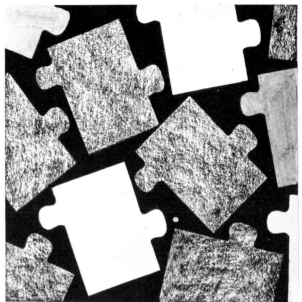

Superimposed shapes

Exciting results are possible by a freer placing of the unit and by allowing it to overlap in part upon shapes already drawn. See also *figures 44* and *89*, pages 43 and 80.

Random placing

Instead of the discipline of repeat, shapes may be drawn at random, being allowed to touch but not overlap. Again, colour might play an important part in such designs. *Figure 119* illustrates the use of random placing to build up a design. See also *figure 3*, page 11.

118 *Superimposed shapes*

119 *Random placing*

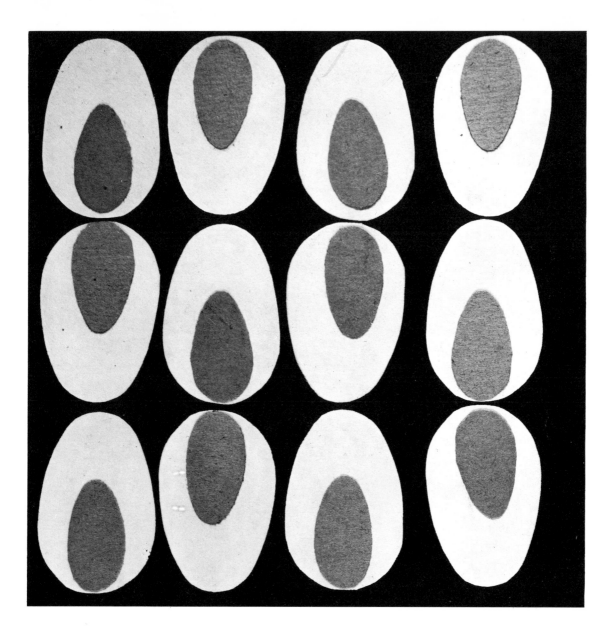

120 *Assembled design using paper units*

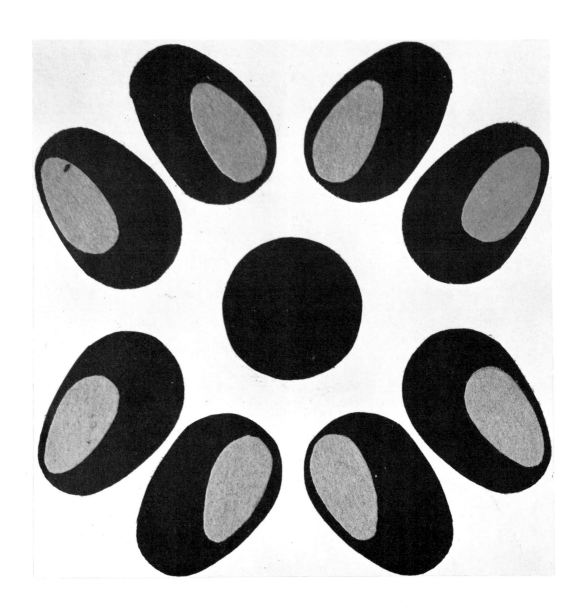

121 *Assembled design*

Assembled repeats

Units can be cut from various materials and glued on to a support. The type of support is determined by the materials to be glued on to it. Paper, card, canvas, hardboard, fibreboard, composition board, or plywood might be used as supports, the units being cut from materials like coloured paper, tissue, card, Perspex, Plexiglas, plastic, polystyrene, hardboard or wood. Units could be confined to one material or the picture built up by using a variety. The kind of glue used must also relate to the materials.

If thin paper is used, a number of units can be cut out at once. A template might be needed where units are to be cut from thicker materials. Scissors, a sharp knife, a hacksaw or fretsaw may be required to cut out shapes, depending on the materials being used.

In *figure 120* the shapes have been cut from paper. In *figure 121* the basic shape (white) was cut from folded paper, then glued down on to paper of a different colour. Smaller shapes were added in the spaces. See also *figures 129, 132, 133, 143* and *152*, pages 111, 113, 119 and 127.

Drawings

Drawings may also be built up by repeating a shape and various drawing techniques may be applied to this. A combination of media often produces more interesting results.

Figure 122 shows a rubbing from a plastic 'found' template. See also *figure 44*, page 43, and the section on drawings.

Spray techniques

Templates of paper or card may be used to mask out areas while shapes are sprayed in. The template may be used as a positive or negative shape. See *figure 94*, page 84, and the section on templates.

122 *Rubbing of plastic template repeated to form a design*

6 Assembled abstracts

Shapes cut from various materials and glued on to a support can give very exciting results. The type of support will be determined by the materials being used. Paper, card, canvas, hardboard, fibreboard, composition board or plywood might be used as supports, while shapes can be cut from materials such as coloured paper, tissue, card, Perspex, Plexiglas, plastic, polystyrene, hardboard, fibreboard, composition board or wood. Shapes may be confined to one material, or the picture built up by using different materials.

The size of the work, the glue and the type of cutting tool to be employed will likewise depend upon individual materials. Scissors, a sharp knife, a hacksaw or a fretsaw will be required for cutting out.

Interesting contrasts can be achieved by introducing relief, remembering that the shadows play an important part in the design. Painted areas might be contrasted with those in relief.

Picture building with cut shapes

Shapes are cut and arranged on the support. When a satisfactory design has been worked out, the shapes are glued in position. One must bear in mind that the shapes relate to each other as well as to the whole. Colours, textures, the type of materials to be used and their spacing must be carefully thought about.

Figure 123 shows a simple design using cut shapes from black art paper.

In *figure 124* the design involves the use of coloured papers.

In *figure 125* squares cut from various papers have been used to make the design.

Figure 126 shows a painted design cut into squares, rearranged and glued.

Figure 127 illustrates a sheet of paper with holes punched in it which has been cut into squares, rearranged and glued.

In *figure 128* ring reinforcements have been used.

Figure 129 shows the use of shapes cut from textured paper. The textures were created by obtaining rubbings of various surfaces on sheets of paper. The shapes were then cut out in duplicate.

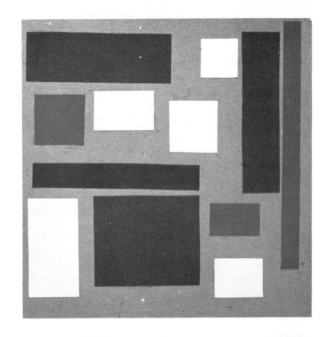

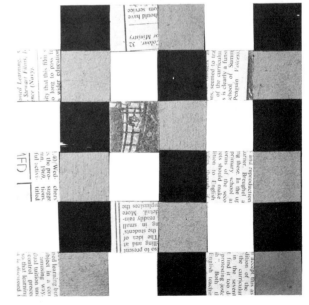

123 *(above left)* *Simple design with cut paper shapes*

124 *(above right)* *Cut shapes of various colours*

125 *(below right)* *Assembled design using squares cut from four different kinds of paper*

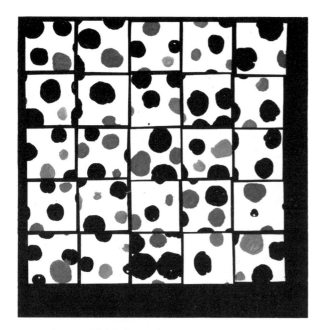

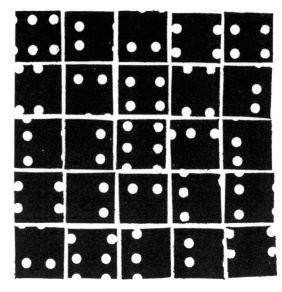

126 *(above left)* *Painted design, cut and rearranged*

127 *(above right)* *Design from punched paper, cut and rebuilt*

128 *(below left)* *Ring reinforcements*

129 *Using shapes cut from textured paper*

In *figure 130* the basic design is made up of two pieces of white paper which have had shapes cut from them. The two pieces are identical, the lower left-hand edge equalling the top right-hand edge. Further shapes of a different colour have been added in the spaces.

A great many possibilities arise by cutting shapes from two or more pieces of material at once and then subdividing them. The different shapes thus formed can be used to build a picture. *Figure 131* was made from two circles used in this way.

130 *(above)* *Assembled design from cut paper shapes*

131 *(below)* *Building from divided shapes*

Shapes cut en masse may be used to make a design, as in *figure 132*. Here, other shapes have been glued on to the basic ones to add interest.

Figure 133 illustrates circles of the same size but making use of different colours and overlapped areas. The superimposed circles were cut from tissue paper.

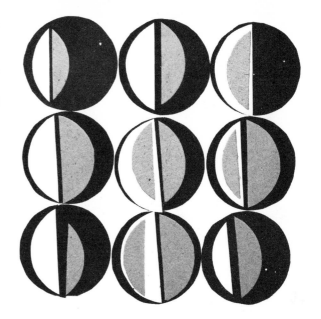

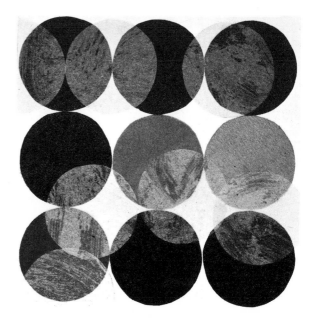

132 *(above)* *Building with shapes of different colours*

133 *(below)* *Using overlapped shapes*

Dividing

Paintings which seem very dull can often be enlivened by subdivision, rearranging the shapes and gluing them down. Drawings, ink designs, rubbings, blot designs, etc may be used similarly. Division may be into strips, vertically, horizontally or diagonally, or by cutting out squares, triangles, circles, etc of exactly the same size. Vertical and horizontal strips need not be of equal width. After cutting, the picture is rebuilt by arranging the parts in a different order.

Figure 134 shows a division into equal strips

which have been arranged in a different order, prior to gluing down on another sheet of paper. The advantage of cutting into strips is that the parts do not have to be identical. The strips can also be reversed.

Figure 135 is a most interesting design formed by subdivision into diagonal strips. Here the strips have to be of equal width. It was rebuilt by taking alternate strips from bottom left and top right and assembled from the bottom left-hand corner inwards.

134 *Division into strips*

135 *Division into diagonal strips*

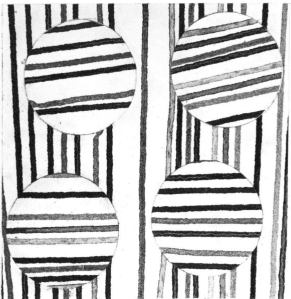

Figure 136 shows a textured drawing in pencil and charcoal which has had squares cut from it. The squares were then rearranged and the whole glued to another sheet of paper.

In *figure 137* paint which has been allowed to run forms the basic design; see also *figures 17* and *18*, pages 20 and 21. Circles were cut out and replaced in different positions.

Subdivision leads to numerous possibilities. It would be possible, for example, to cut other shapes from those first cut out.

136 *Rearranged squares*

137 *Rearranged circles*

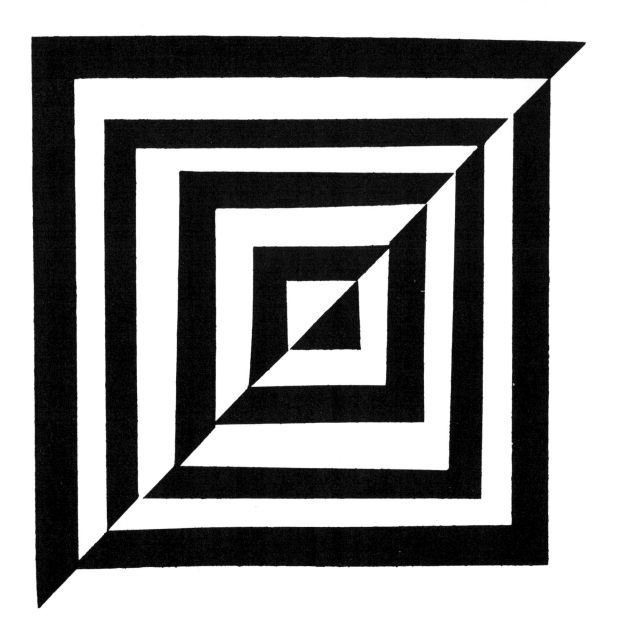

138 *Expansion of a triangle*

Shape expansion

As the name suggests, this involves cutting parts from a basic shape and using these to expand it.

Figure 138 shows a triangle which has been divided into successively smaller triangles. When the shapes were cut out they were glued opposite the space from which they came, thus forming an extension of that shape.

Very often the character of the original shape is changed completely by division and expansion. In *figure 139* strips have been cut diagonally into a square, and again used to extend the space from which they were cut. *Figure 140* shows the division of a rectangle, and *figure 141* the expansion of a square.

With all these examples nothing was added or taken away from the original shape. Thin materials such as paper and card are the most suitable as these can be cut with scissors or a sharp knife.

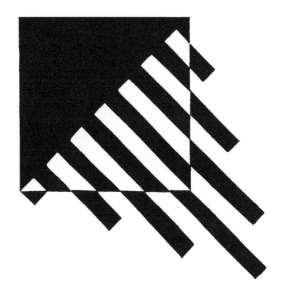

139 *(above)* *Expansion of a square*

140 *(below)* *Expanded rectangle*

141 *Expansion of a square*

Silhouettes

Again shapes are cut from a basic shape but this time the cut-out parts are disregarded, so as to leave a silhouette.

There are four main ways of approach: to cut shapes from the edges; to cut shapes from the interior; to cut on a fold or folds; or to cut from both edges and interior.

Figure 142 shows interior cuts to form a silhouette. The parts cut out to form silhouettes need not be thrown away but can be used to make other designs, as in *figure 143*.

In *figure 144* the silhouette was formed by cutting triangular shapes from the edges of a square.

Generally speaking, silhouettes should be confined to a small scale and are most effective if black on white or white on black.

Silhouette work is simple to execute but very often produces exciting results. It may provide useful introductory work to more complicated techniques with cut paper.

Interesting silhouette shapes may be formed by shadows. If drawn round the shapes can be cut out and used as silhouettes.

142 *(above)* *Silhouette : interior cuts*

143 *(below)* *Design made from the cut out parts of figure 142*

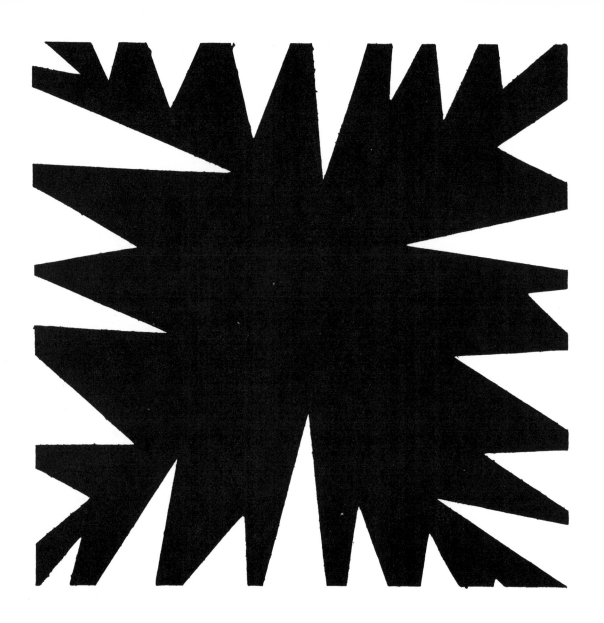

144 *Silhouette : making cuts from the edges*

Cutting through several layers

If several layers of different coloured material are used pictures may be rebuilt using shapes of each colour. The rebuilt design is then glued to a suitable backing.

Figures 145 and *146* were made in this way. Black and grey sheets of paper were used here, placed together so that identical shapes were cut from both. The squares were then rebuilt on white paper using some shapes of the other colour, and leaving some areas white. The thickness of the material will determine how many sheets of it are cut through at once; with thin paper it is possible to use perhaps four or even more layers together. The rebuilt shapes can be used in a composite way to form one larger picture.

Figure 147 shows a positive/negative design assembled in the same way.

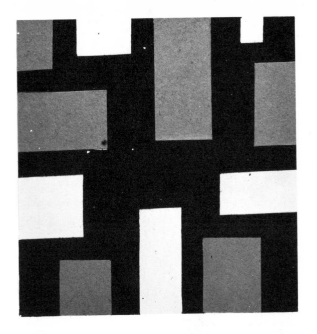

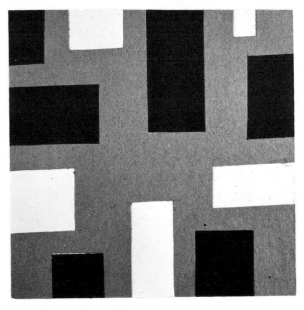

145 *(above)* *Cutting through several layers*

146 *(below)* *Cutting through several layers*

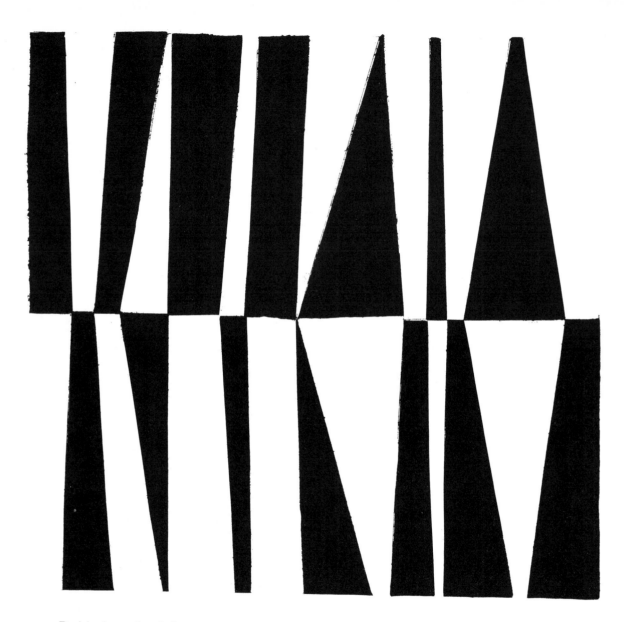

147 *Positive/negative design cut from two layers of paper*

Tearing

Exciting abstract pictures can result from the use of torn shapes. A single material can be used or alternatively a variety of textures and colours. The shapes may be used individually or allowed to overlap. Using card, paper and various fabrics large scale work is possible.

Figure 148 shows a design made with torn strips of paper, while *figure 149* uses torn shapes of various colours and textures.

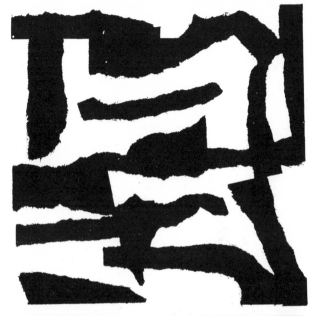

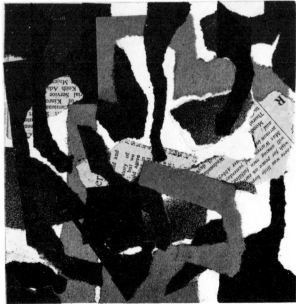

148 *(above)* *Using torn strips of paper*

149 *(below)* *Using torn shapes of various colours*

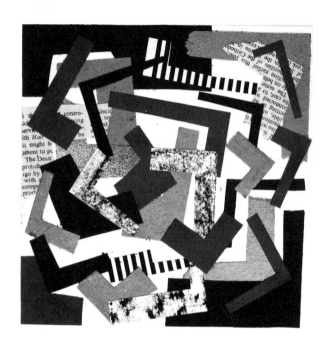

Collage

The design may be built up from pieces of paper, cloth or other material stuck on to the support. The shapes may be cut or torn.

In *figure 150* a similar cut shape is used with variety of colour and texture.

Pictures may also be assembled from shapes cut out of magazines, supplements and newspapers. *Figure 151* is such an example.

150 *Collage*

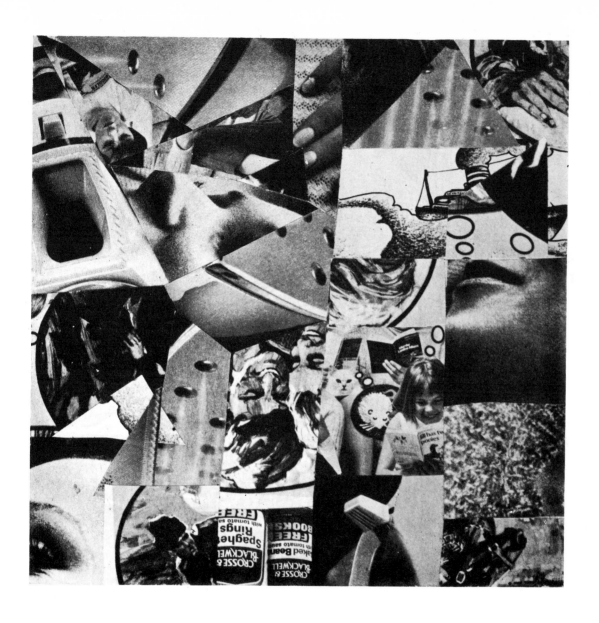

151 *Assemblage from shapes cut out of magazines*

Combining media and techniques

As well as colour and shapes one might also consider the surface or texture of the picture. Abstract pictures may rely heavily upon surface variations or textures for their effect. This book concerns itself with picture-making in two dimensions rather than three but the possibilities of relief pictures should be mentioned. Likewise, interesting results are possible by combining different media or employing several techniques within the one painting.

Relief pictures will usually be large and must, of course, be constructed on a solid base such as backed hardboard or plywood. Variations of surface might be achieved by layers of hardboard, fibreboard or composition board shapes or strips of wood glued on. Painted shapes can then run across these different levels. Interesting pictures can also be made with nails and screws, or other shapes such as empty tin cans or lengths of cardboard tubing glued on. Alternatively the surface might consist of plaster or thick paint such as pva or acrylic paint into which various objects are impressed or allowed to set. These pictures can be sprayed or painted in some other way.

Painted and assembled techniques can be used together to form a picture. Many variations are possible and the reader is encouraged to explore some of them.

Figure 152 shows the combined use of paper shapes and drawn shapes.

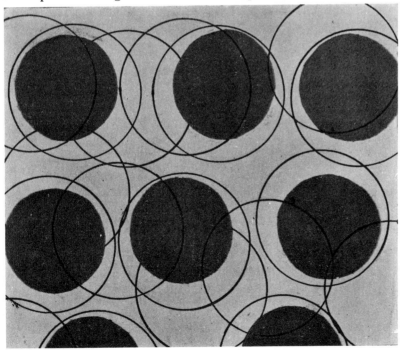

152 *Combining media*

Further reading

For general reading on the history of Modern Art:
A Concise History of Modern Painting, Herbert Read,
Thames and Hudson
Art Now, Herbert Read, Faber
Abstract Art Since 1945, Thames and Hudson
Movements in Art since 1945, Edward Lucie-Smith, Thames
and Hudson
Modern Painting from Manet to Mondrian, Joseph-Emile
Muller, Methuen
Modern European Art, Alan Bowness, Thames and Hudson
Modern Art Movements, Trewin Copplestone, Paul Hamlyn
Pop Art, Lucy R. Lippard, Thames and Hudson
*The New York School : Abstract Expressionism in the
40s and 50s*, Editor, Maurice Tuchman, Thames and Hudson

For reading and reference:
Larousse Encyclopedia of Modern Art, Editor, Rene Huyghe,
Paul Hamlyn
A Dictionary of Modern Painting, Editor, Carlton Lake and
Robert Maillard, Methuen
A Dictionary of Art and Artists, Peter and Linda Murray,
Pelican
Painting Materials, A Short Encyclopedia, Rutherford J.
Gettens and George L. Stout, Dover Publications,
New York
Formulas for Artists, Robert Massey, Batsford
The Technique of Kinetic Art, John Tovey, Batsford,
London, Van Nostram Reinhold, New York
Pop Art in School, Florian Merz, Batsford, London,
Van Nostram Reinhold, New York

Suppliers

Great Britain

Paints, crayons, inks, paper and all art materials

Fred Aldous, The Handicrafts Centre
37 Lever Street, Manchester 760 1UX
E. J. Arnold, Butterley Street
Leeds LS10 1AX
Arts and Crafts, 10 Byram Street
Huddersfield HD1 1DA
Brodie and Middleton Limited
79 Long Acre, London
Crafts Unlimited, Macklin Street, London WC2
Dryad Limited, Northgates, Leicester
Educational Supply Association, Pinnacles
Harlow, Essex
Margros Limited, Monument Way West
Woking, Surrey
Clifford Milburn Limited, 54 Fleet Street
London EC4
Nottingham Handicraft Company, Melton
Road, Westbridgford, Nottingham (not paints, inks or crayons)
Reeves and Sons Limited, Lincoln Road
Enfield, Middlesex and branches
George Rowney and Company Limited
10 Percy Street, London W1
Winsor and Newton Limited, Wealdstone
Harrow, Middlesex and branches

Crayons may be ordered direct from
Cosmic Crayon Company, Ampthill Road, Bedford
Harbutt's Limited, Bathampton, Bath, Somerset
Scholarship Industries Limited, Manor Lane
Holmes Chapel, Cheshire

Felt-tip pens

Mentmore Manufacturing Company Limited
Six Hills Way, Stevenage, Herts
Speedry Products Limited, Copers Cope Road
Beckenham, Kent
also from most stationers or general stores

Raw canvas

Russel and Chapple, 23 Monmouth Street
London

USA

Paints, crayons, inks, paper, brushes, adhesives and all art materials

Grumbacher, 460 West 34 Street, New York
The Morilla Company Inc, 43 21st Street
Long Island City, New York and
2866 West 7 Street, Los Angeles
California
*New Masters Art Division : California
Products Corporation*, 169 Waverley Street
Cambridge, Massachusetts
Stafford-Reeves Inc, 626 Greenwich Street
New York, NY 10014
Winsor and Newton Inc, 555 Winsor Drive
Secaucus, New Jersey 07094

Felt-tip pens

Magic Marker Corporation, 88 and 73 Avenue
Glendale, NY
Nobema Products Corporation, 91 Broadway
Jersey City, New Jersey
The F. Weber Co, Wayne and Windrim Streets
Philadelphia, Pennsylvania

Most of the materials are available from
local art supply stores, hardware stores,
timber merchants, and ironmongers